The Jewish Pope

A Yiddish Tale

by

Yudel Mark

translated by

Ruth Fisher Goodman

illustrated by

Connie G. Krupin

Ruth Fisher Goodman

2006 • Fithian Press, McKinleyville, California

Published by Fithian Press
A division of Daniel and Daniel, Publishers, Inc.
Post Office Box 2790
McKinleyville, CA 95519
www.danielpublishing.com

Distributed by SCB Distributors (800) 729-6423

LIBRARY OF CONGRESS CATALOGING-IN-PUBLICATION DATA
Mark, Yudel, 1897–1975.
 [Yidisher poyps. English]
 The Jewish pope : a Yiddish tale / by Yudel Mark ; translated by
Ruth Fisher Goodman.
 p. cm.
 ISBN 1-56474-459-0 (pape : alk. paper)
 I. Goodman, Ruth Fisher, (date) II. Title.
 PJ5129.M33Y513 2006
 839'.133—dc22
 2006016808

Dedicated to the memory of

Yudel Mark,

*my teacher, who taught me to
appreciate Jewish culture and
take pride in my heritage*

✒ Contents

Part One

The Confessional .9
A Soul for a Soul .10
Little Elkhanan .12
The Legend of Rabbi Amram13
Bitter Herbs to Cure a Cough16
The Sabbath Disrupted18
The Three Mirrors .20
Father Thomas .22
The Devil .24
The Child Escapes .25
Alone in the Forest .26
The Fever .28
Father Felix .32
Elkhanan Remembers a Legend34
Brenner Pass .36
An Audience with the Pope38
The Pierleone Palace .40
A Discussion .41
A Letter .43
Pierleone's Son .45
The Pope Who Hid .47
On the Eve of Great Events49
Alone at Night at the Lateran50
The Dead Jews of Mainz Numbered 1,01452
Tropea, Sister Mine! .54
The Cardinal of Trastevere58
Just a Jew .59
The Knight of Red Rock Castle61
The Clever Solution .63
Rebecca and the Pigeons64
Pierleone the Elder Dies66
The Legal and Illegal Pope67

Part Two

Father and Daughter .71
At the Gates of Rome .72
Jew Street .74
The Rabbi and the Torah76
The Voice of a Girl is Heard78
Two Expressions .80
"We Do Not Want the Jew!"82
A Letter from His Sister84
Drawn to His Roots .86
In the Synagogue .88
Stories Heard Long Ago89
On the Night of Kol Nidre91
"That is He!" .93
Under the Arch of Titus95
Rome and Jerusalem .96
A Thief or a Spy? .97
The Illegal Pope .99
Bishop Thomas .100
The Abandoned Pope102
In an Underground Cave103
A Suspect is Captured105
The Last Encounter with Father Thomas107
Thomas's Punishment109
The Blind Beggar .111
The Rabbi of Mainz .113
The Restrictive Law
 Against the Jews of Mainz115
It Cannot Be! .117
The Delegation .118
A Round of Chess .120
Father! Father! .122
Someone Jumps Off the Roof124
Do You Know Who He Is?126

Part One

The Confessional

It was that time of year when Jews were preparing to celebrate Passover, but winter was dragging on and it was still so cold.

Theresa shivered as she drew her shawl tightly around her. She was a poor woman; a devout Catholic. She had gotten up very early this morning, so that she would be the first to get to church and confess her sins. But when she got there, many women, just as poor as she, were already waiting to see the priest.

She leaned against the cold wall as she waited her turn, all the while her lips moving, mumbling words that were unintelligible. Finally, she reached the confessional and spoke through the narrow window that separated her from the priest, just as she had done so many times before. And, as she had done so many times before, confessed the bad thoughts she held of her husband....

"He gets drunk. He beats me.... I work hard.... I must be the breadwinner. If it were not for the Jews, I would have died of hunger long ago. I am grateful that Jews are forbidden to light the fire in their stoves on the Sabbath and call upon me to perform this service."

An angry voice interrupted her from behind the window. "Have you come here to praise the perfidious Jews! You are committing your soul to hell!"

"I have not come to praise the Jews," she replied meekly. "I just wanted to tell you that they give me Challah (Sabbath bread) and other foods. And they give me money for lighting their ovens. They also give me—"

"You are forbidden to work for Jews!" shouted the voice behind the narrow window. "It is the biggest sin of all and the church will never forgive you!"

Theresa sobbed. The voice behind the window whispered into her ear: "The church will never forgive your sin. You will burn in hell forever. Your hands will be bound in chains; chains that will rip into your skin."

Theresa began to cry hysterically.

"Go! There are others waiting!" the priest yelled. But Theresa did not move. She had such a hard life and now she had this to look forward to in the hereafter? How could she leave still impure and without absolution? She sat as though glued to the seat.

"Go. Come back early tomorrow morning and I will talk to you," the priest said in a somewhat calmer tone. "Go, others are waiting."

🖋 A Soul for a Soul

Early the next morning, Theresa stood before the priest with eyes red and swollen from crying, her body shaking with fear. It was Saturday, her best day.

It was the day that she would go into Jewish homes and light the ovens. Compensation for this service would sustain her for the next few days. But first she must go to the Holy Church and be absolved of her sins.

Except for her, no one else was there. Today, the priest was good to her. He didn't yell, nor was he angry. Once again, he heard her out, but this time without interruption. When she was through, he said, "You have committed the sin of working for the accursed Jews. That is the biggest sin you could commit, but the Church will be good to you and forgive you if you will bring another soul into the Church. Bring a Jewish child into the Church and you will be absolved of your sin."

Theresa stopped crying. "A Jewish child?" she asked in wonderment. "How can I do that?"

"Yes, a Jewish child to be converted to Catholicism," answered the priest.

"But how can I do that?" she asked.

"If you really want to be forgiven, you will find a way," said the priest. "Bring me a Jewish child. And bring me the child *today!*"

Theresa threw herself at the feet of the priest. She wanted to say more. She wanted to plead for a different punishment, but when she raised her eyes, she saw that she was alone. The priest had gone. She got up, unsteady on her feet, and with an uneven gait walked slowly out of the church.

〜 Little Elkhanan

Theresa went into the street and saw Jewish families walking leisurely to the synagogue for the Sabbath service. They were dressed in their Sabbath best, children scrubbed clean and on their best behavior. The Rabbi was among them. Rabbi Shimon was taller than average; he walked erect and had a long beard. Slightly apart from him was his wife, the Rebbitsen. She was such a good and kind woman! She had given Theresa clothes as well as Challah and fish. Now she smiled at her as she saw her coming out of church.

A fleeting thought crossed Theresa's mind. Why isn't their son with them? She would soon find out. The first house she serviced on Saturday was the Rabbi's. When she arrived at the Rabbi's house, she found the old housekeeper, Golda, and the Rabbi's five-year-old son, Elkhanan.

"It's good that you came," Golda said to Theresa. "Elkhanan is not well. He has a cold and a terrible cough."

After the wood started to burn in the oven, little Elkhanan went to sit in front of the warm stove with Golda, who then continued the story she had started before Theresa arrived.

"Once in Mainz there was a big fire. The fire started in the Jewish quarter, but the wind carried the sparks and ignited the neighboring streets where the Christians lived. Almost the entire city was burned

down. The fire started at night, turning the sky and everything else red. We barely escaped with our lives! Everything we owned was engulfed in flames and destroyed. The Christians blamed the Jews for having started the fire and we were no longer welcome to remain in Mainz, so we moved to Speyer. There the Jewish community welcomed us and took us in. They wanted your father to remain with them and be their spiritual leader; but no, he wanted to return here as soon as was possible. Your father is so greatly respected."

"I know that story," little Elkhanan said, " but I don't know why the Christians blamed the Jews for the fire. The Jews suffered more from the fire than the Christians did."

"Why they did?" said Golda. "Ask them!" And she turned to Theresa with a nod of the head.

"But they can't harm us when God watches over us!" said Elkhanan proudly. "That's what my teacher told us. But I like it better when you tell me the story."

✍ The Legend of Rabbi Amram

"Good," said Golda, "but now you must take herbs to cure your cough and I'll tell you more stories." She continued: "This story is about Rabbi Amram. When Rabbi Amram was dying, he told his students not to bury him in Cologne, for fear that the Christians

would claim his body and bury him in a Christian cemetery. He instructed his students to place his body in a boat and let it sail down the Rhine. He said the boat would find its own place to stop and that wherever it landed would be his final resting place. The Rabbi's faithful students honored his wishes. They placed his body in a coffin and placed the coffin in a boat. To everyone's amazement, a miracle occurred. The boat did not sail with the current, but against it. The boat stopped at the big bridge over the Rhine in Mainz, where there was a large Jewish population. The Christians tried to reach the boat with cables and bring it closer to shore, but the boat twisted and turned and all their efforts failed. But when the Jews tried to bring it in, the boat sailed easily to the shore. Jews kept watch over the coffin all day and all through the night, as is the prescribed ritual. The Christians knew of the instructions the Rabbi had given and tried to prevent the students from carrying them out. It just so happened that beyond the city limits a robber was hanged that very day. The Jews decided to replace the Rabbi's corpse with that of the robber's. They buried Rabbi Amram that night in a Jewish burial service. When the Christians came to claim the coffin, they were surprised that it was not as heavy as they expected. With great fanfare and a big parade, they marched with the coffin to the Christian cemetery. Instead of burying the pious Rabbi, they unknowingly buried the robber."

🐦 Bitter Herbs to Cure a Cough

"You see!" called out little Elkhanan, who had been so engrossed in the story of Rabbi Amram that he didn't even cough once. But as soon as the story was over, he was unable to stop coughing. Golda gave him bitter herbs. The child took the herbs without complaint. It helped somewhat, but after a short while, he began to cough again.

The fire in the oven had gone out. Theresa closed the oven door. Ordinarily, she would have left to go on to the next house, but today she was in no rush. She lingered.

"What a dear child!" she said to the old Jewish housekeeper. "What a pity he has such a terrible cough."

"But what can I do?" replied Golda. "He's dressed warmly. He missed school yesterday and today he is unable to go to the synagogue for Sabbath service."

"I know of a special herb that cures the worst cough quickly," said Theresa. "One only has to drink the mix a couple of times and the cough is gone."

"Where can I get this herb?" asked the housekeeper.

"I have it!" responded Theresa. "Dress him warmly and put a shawl around his neck. I'll take him to my house and give it to him."

"I think it would be better if you brought the herb here," Golda said. "I don't think it's a good idea to take him outside."

"You know my husband, the drunk! If I were to take the jar of herbs out of my house, he would kill me!" replied Theresa. "But if I have the child with me, I don't think he would object to my giving him a little bit. My husband watches over the jar of herbs as though it were his greatest treasure. You know I don't live far from here. I'll bring the child back right away. What are you afraid of? It's no big deal. I'm not going to kidnap him."

Elkhanan listened to every word that was said, and called out, "Don't worry, Golda, I won't let anyone kidnap me!"

Golda put the shawl around Elkhanan's neck and watched Theresa walk out the door with the child. She picked up her prayer book and began to pray. As time went by, she became more and more disquieted. Where was the child? Why hadn't Theresa brought him back yet? Her thoughts raced. "Oh my! What have I done?" she said in a barely audible whisper.

She wrapped her shawl around her and ran out into the street. The street was empty. She ran into the side street, where Theresa's house was located. No one was there. In a panic, she ran up and the street like a mad woman. "Where is the child? What have I done? Where is the child?" she cried.

⁊ The Sabbath Disrupted

Rabbi Shimon was on his way home from the synagogue, walking leisurely. The Rabbi's wife was with him. She wanted to get home quickly, but it was after all the Sabbath, and one doesn't walk hurriedly on this holy day. Something was bothering her, but she didn't know what.

Rabbi Shimon opened the door, ready to call out a cheerful "Good Sabbath," but neither Golda nor Elkhanan was in the house. He wondered why the table wasn't set as usual for the Sabbath meal.

"Where has Golda taken the child?" asked the mother. "The child has such a terrible cough!" With a quiver in her voice, she added: "Something in my heart told me that...something was not right."

"She will soon return with Elkhanan," said the Rabbi, trying to comfort his wife; but he himself was very uneasy.

The Rebbitsen began to set the table. The wine bottle was on the table, ready for Rabbi Shimon to say the blessing, but he waited. He loved to hear how his son said "amen" after the blessing. He was such a wonderful child, so bright. He absorbed everything like a sponge. Just a short while ago, the Rabbi had taught Elkhanan how to play chess, and already he played like an adult. He caught on to the game so quickly! One day he would be a great Rabbi and a leader of our people!

Suddenly, the door opened and in rushed the old

housekeeper crying convulsively as she told how Theresa had taken the child and how she had run all over searching for them. "No one has seen them and no one knows where they are."

Neighbors began to gather around the Rabbi and the Rebbitsen when they heard about the tragedy. "Yes," they confirmed that Theresa had taken the child. The neighbors told them that Theresa hadn't come to any of their houses to light the firewood in the ovens.

The neighbors tried to console the parents. "Maybe she wants money? Maybe her husband, the drunkard, forced her to kidnap the child for ransom?"

A few of the younger men said they would stand watch over the drunkard's house. The Rabbi went to city hall, where he was promised that the police would help search for the child. Even though it was the Sabbath, saving a child was of greater importance than the observance of this holy day, and took precedence over all else. So everyone went out to search for Elkhanan and Theresa. They were nowhere to be found! They found only Theresa's husband—in a tavern, stone drunk. They tried to get through to him. He swore he knew nothing of the matter. Slurring his words, he said, "If I find her, I'll break every bone in her body!"

And now it was late at night and a devastated mother lay across her bed and was weeping uncontrollably. A pained and weary father sat at the table, head in hand, and dozed on and off.

◈ The Three Mirrors

The Rabbi was being taken far, far away. They took him into a very large room. It was frightening. He saw a tall chair, a throne. On the throne, wearing a red cloak, was Elkhanan. Everyone around him was bowing. He, the father, stood before him. Elkhanan said to him, "Don't be frightened, my father. I am your faithful son and I have a gift for you for coming such a long way to see me. I have three magic mirrors for you: In one, you will be able to see all that has happened in the world in the past. In another, you will be able to see everything that is happening in the present, and in the third, you will be able to see the future. But take care, Father. Don't cry. Father Abraham didn't cry when he bound his son on the altar. My regards to mother and tell her not to cry either."

Suddenly, the vision disappeared. On the table were three mirrors. Rabbi Shimon looked into the first mirror:

He saw so many images! He knew them all. Here, he saw a battle. A king was in danger; his enemies were surrounding him and killing his horse. Rabbi Shimon saw his great-grandfather giving his horse to the king, thus saving his life. For this, the king gave him a reward and brought him to Mainz from Italy.

He saw the Jews being driven out of Mainz. They were expelled because a well-known priest had converted to Judaism. So all Jews had to leave. Now, he saw himself!

He was walking to Speyer. His wife was carrying their two-week-old child. Suddenly, a man in a black cloak wrenched the child from his mother's arms and covered his mouth…oh, the child might suffocate.…

A tear from the Rabbi's eye fell onto the mirror, and whoosh, the mirror turned into ashes.

Rabbi Shimon looked into the second mirror. What was this? Tears clouded his eyes and he could not see clearly. Was it a small chamber? Was it a small child huddled in a corner? The child had been beaten! There were welts on his face! The child was crying. He was saying something. But the Rabbi couldn't hear what it was. Maybe he was calling, "Father, save me!"

It was his child! It was Elkhanan!

The tears rushed down the Rabbi's face and fell on the second mirror. The second mirror turned into a mound of ashes.

He would not cry any more! He had to know what was to become of his son! Even if it was horrible. He would steel himself not to shed another tear!

He looked into the third mirror. So many people! People were marching to war. Everyone was screaming and laughing wildly. They arrived at the gates of Mainz. So much blood! Are people being killed? Jews? Suddenly, he was alone! He ran into a garden and hid. Would any Jews survive in Mainz? His enflamed, dry eyes looked upon the disaster that was to come in the future. He had to see Elkhanan! He did see him! He was wearing a big cross on his chest. This was far be-

~21~

yond the Rabbi's strength to endure. A tear fell on the mirror. The third mirror turned into an ash.

Just as the third mirror disintegrated, the unfortunate mother screamed out from her sleep. Rabbi Shimon was jolted awake and jumped out of his chair.

Father Thomas

"Theresa, why are you walking so fast? You're pulling me! I can walk without holding your hand!" said Elkhanan as he tried to wrench his hand from Theresa's grip. He was frightened and wanted to run home.

Theresa did not answer but quickly picked Elkhanan up in her arms and ran with him, stepping in puddles so that they were both splattered with mud. A tall person came toward them. It appeared that he came through a small door.

"Father Thomas! Father Thomas!" Theresa ran toward him.

Father Thomas tore the child from her arms. Elkhanan kicked and screamed. The man stuffed the child's mouth with a piece of cloth and flung him over his shoulder, covering him with his long black cloak. They both disappeared through the small door. Theresa ran after them, crying, "Let the child go. I changed my mind. I'll take him back to his parents. Let him go! Let him go!" she pleaded.

"Quiet, you foolish woman! You are a lost soul, but if you do as I say, you will be saved. If you do not

obey me, the Jews will kill you. This is not a child. It is a devil!" Father Thomas screamed at her just as Elkhanan kicked him hard.

They all walked into a small house that stood in a courtyard. The priest put the child down and removed the cloth from his mouth.

"Stay here," he ordered Theresa. "Don't you dare try to leave! No one leaves here. Nothing you do will change my mind, so stop your tears and your pleas. You will spend the night here and in the morning my servant will take you far away from Mainz so the accursed Jews can not get to you."

He locked Theresa in the chamber, lifted the child, and walked through an underground tunnel with him. Elkhanan kicked as hard as he could and began biting him. Father Thomas beat him unmercifully and threw him into a dungeon at the end of the tunnel, locked the door, and left.

Elkhanan was left alone in the dark. He cried himself to sleep. The cold air woke him. It was still dark and he was frightened. He was hungry. He tried to scream, but the echo in the empty room frightened him even more. He huddled in the corner and leaned against the wall. It was cold and damp. He cried, and began to pray. He said all the prayers he had committed to memory and repeated them many times before he fell asleep.

When he awoke, he saw a beam of light coming from he knew not where. He heard the door squeak. It opened and there stood Father Thomas.

✒ The Devil

Frightened, Elkhanan moved to the far corner of the cell.

This time, Father Thomas's demeanor had changed. He sat down beside the child and spoke kindly. No one wanted to harm him. They wanted to keep him safe. They would bring him food and give him a nice room. They would buy him new clothes and get him anything that he wanted. But in return, he must be obedient and do all that was asked of him.

"I want to go home," he cried out.

"You're going to have a new home, a very nice home," Father Thomas said as sweetly as he could and continued to tell him how happy he would be there. At this, he led Elkhanan out of the dungeon and through the tunnel into a beautiful room. An elderly woman washed him, dressed him new clothes, and brought him some food. Elkhanan did not move toward the food. The old woman tried to coax him to eat. "Why won't you eat?" she asked.

"It's not kosher!" he responded.

She left the room and locked the door, leaving all the tempting food on the table. No one came in. Elkhanan did not go to the table. This was how he spent the entire day.

At night, Father Thomas came into the room with another priest and saw that nothing on the table had been touched.

"They aren't children," he said, "they're devils! He hasn't eaten anything in two days! He'll die of hunger, this devil!"

Both priests then tried to force him to eat. Elkhanan kicked and fought back, shutting his mouth as tightly as he could. He was weak and could not prevent the priests from forcing the food into his mouth. To avoid choking, he swallowed, but as soon as the priests stopped, he put his fingers in his mouth and tried to remove the food.

"He's a devil! A five-year-old child...so stubborn!" said Father Thomas.

"It's not working," said the other priest "We can't force him." And they stopped.

The elderly woman came in and made his bed. She spoke softly to him and asked what foods he would eat. Elkhanan asked for an apple and received it promptly. She brought in more fruit and told him that she would serve whatever foods he wanted.

"I want to go home. Please, let me go home," he pleaded.

☙ The Child Escapes

A few days passed. Then, in the middle of one night, Elkhanan was awakened, dressed warmly, and put into a big wagon. With him was Father Thomas. They traveled all night and all the next day. Only twice did

the wagon stop in order to rest the horses. No one spoke to the child; not Father Thomas, not the wagon driver.

"Where are you taking me?" he asked a hundred times. He cried and pleaded for them to let him know where they were going. But no one answered him.

On the second night of the journey, they stopped at an inn. Elkhanan requested and was given an egg and fruits to eat. The wagon driver went to sleep in the wagon. A bed was prepared for Father Thomas, and beside him, a bed for the child. Elkhanan pretended to be asleep, and as soon as he was sure that Father Thomas slept, he went to where he had observed the priest put the key to the room. He had the key in his hand! On tiptoe, he went to the door and unlocked it. *He was free!* But where should he run?

🦅 Alone in the Forest

Elkhanan stood outside and shivered. It was a cold, windy, dark night; neither the moon nor the stars lit up the streets. For a fleeting moment, he thought he should go back to his soft warm bed. That moment passed quickly.

When his eyes adjusted to the darkness, he started to walk, but had no idea where he was heading. Softly he cautioned himself not to run, and steeled himself not to be frightened. As he got a little farther from the

inn, he heard a dog barking in the distance and instinctively began to run. The streets were wet and it was uphill all the way. The cold air blew against his face, and he was barely able to catch his breath. His clothing caught upon a protuberance from a building. He tripped and fell into a puddle. When he got up, he was soaking wet and covered with mud. But he wasn't hurt. He came to a forest, where he leaned against a tree and prayed: "Prophet Elijah, good Elijah, please rescue me. Please take me home!"

Suddenly, he saw glowing eyes coming toward him. Wolves! Quickly, he scrambled up the tree, sat on a limb and clutched the damp trunk, holding on tightly. He looked around. No longer did he see any glowing eyes. He only heard the wind blowing through the treetops. He pressed his cheek against the damp bark, his arms encircling the trunk, and he prayed silently, "Elijah, good Elijah...."

And the good prophet, Elijah, heard the silent prayer and came down to earth in a fiery red chariot, the very same chariot that had taken him to heaven so long ago. He left the chariot among the clouds and lifted Elkhanan out of the tree and carried him into the chariot while covering him with a soft furry cloak. Elkhanan sat in the chariot beside Elijah the prophet, and away they flew. Elijah looked down on Elkhanan and smiled at him. The child felt warm and so good...so very good. Elkhanan turned his head and saw a tall man with a glowing pate and black beard,

his hands outstretched, begging them to take him with them: "My father, my father," the tall man shouted, "take me with you!"

Elkhanan leaned toward Elijah the prophet and whispered, "It is Elisha, your student. Let us take him with us."

Elijah put his arm around the child and said softly, "We can't. We can't stop the chariot. Father Thomas will catch up with us. We must get as far away from him as possible!"

"Yes, dear Elijah. We must get far away from him," Elkhanan said.

"Hold tight! Hold onto me tightly so that you don't fall out of the chariot," cautioned Elijah.

The Fever

Dogs were barking! Riders were approaching. It was early morning. The child shivered. He had fallen out of the chariot and he was sure he would suffer at the hands of the priest. Elkhanan decided to sit very still. Maybe no one would see him. Good! The men walked past him! But, oh, they stopped, turned, and looked back. The dogs, sensing something, rushed to the tree. A large black dog with pointy ears jumped up on the trunk and barked furiously, all the while jumping up and down.

The mean, angry voice yelled. It was the voice that Elkhanan recognized as his captor's:

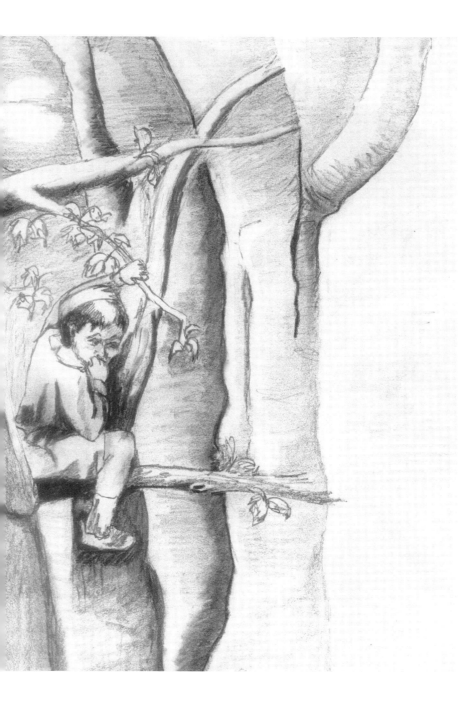

"Climb down from there, you devil!" Father Thomas shouted, livid with rage.

No, Elkhanan would not say a word! No, he would not climb down! He pressed closer to the tree trunk. Maybe a miracle would happen. Maybe the tree would split in half and swallow him up. Just like what happened to the prophet Isaiah when the wicked king ordered him killed. Elkhanan attempted to climb higher. He misstepped and fell from the tree. He was caught, but he didn't have the energy to kick his tormentors. The tears rolled down his cheeks and he felt so hot; he was burning up!

Someone carried Elkhanan to the wagon. He knew not where they were going. It seemed to him that the wagon was moving. He was so cold! Why wasn't his mother covering him with a blanket? Who was this who was sitting beside him? Was it Thomas or the good Elijah? Oh, had Elijah come to him?

Now it seemed to him that he was in a bed and a lamp was lit on a table. Where was he? He opened his eyes and saw an old man standing beside the bed. The old man smiled at him and said in a soft, gentle voice, "Are you feeling better?"

"I want a drink."

"Wait, I'll hold your head up, so it will be easier to drink from the cup."

"Thank you," said Elkhanan.

"You're a good child and soon you will be well," said the kindly man. His wrinkled face smiled happily at Elkhanan.

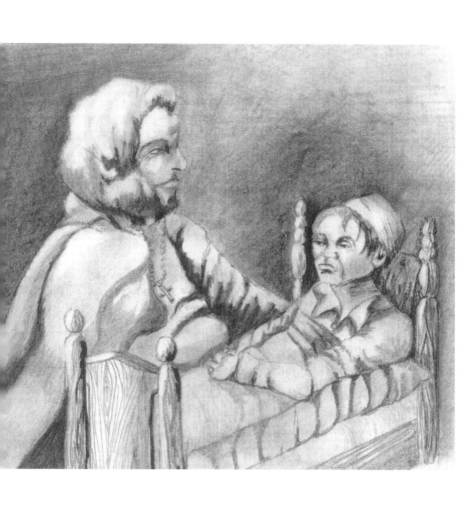

"Where am I?" Elkhanan asked.

"In the Church of Holy Jacob in the city of Bromberg," the man answered.

"How did I get here?"

"You've been here for a week. You've been very sick and we feared for your life. I sat with you day and night waiting for you to recover. And see, now you are better."

"But how did I get here?"

"You were very ill when they brought you here and left you."

"Who are you? What is your name?"

"You may call me Father Felix."

🕊 Father Felix

"I want to go home, Father Felix!" Elkhanan said, and tried to sit up.

"Wait. You are too weak. First, you must get well."

Father Felix did not leave the child's bedside. He gave him medicine and told him stories. He comforted him and told him that he would be going home. Elkhanan was so weak and did everything he was told. He really liked Father Felix, the good priest.

When the little boy was able to get out of bed, he was promised that when he was able, he would be taken back to Mainz. But for now, he must wait. In the meantime, Father Felix said he would be with

him. He would tell him stories and study with him. The good priest would give him only the foods he wanted to eat. He would take care of him and keep him safe from such mean people like Father Thomas, about whom Elkhanan complained.

Summer had come. Surrounding the church was a big beautiful garden. This is where Elkhanan sat with Father Felix and studied. The child still had a cough. Father Felix gave him the necessary medication and gave him delicious treats. He would pat his head and praise him. They were together day and night. At night, they slept beside each other. Elkhanan no longer had the burning desire to return to Mainz. He still wanted to go home, but wanted Father Felix to come with him.

It was hard for Elkhanan not to obey such a good person as the good priest. He thought that he was sinning not to want to return to his home, but he remembered how cold and frightened he had been in the forest when he pleaded to Elijah, the prophet to save him. It was Father Felix, not Elijah who had come to help him.

His thoughts frightened him and he turned very pale.

"What's the matter?" asked the priest.

"I just remembered a story."

"Tell me your story."

✒ Elkhanan Remembers a Legend

"There once was a distinguished and respected Jew who lived in Mainz. Often, he would visit the Bishop and have long discussions with him. The Jew's name was Rabbi Amram. The Bishop would always try to convince the Rabbi to convert, and always Rabbi Amram would refuse. One time, the Bishop argued long and hard with the Rabbi, trying to convince him to convert, and then threatened to banish him if he didn't. The Rabbi responded with a request for three days to think it over.

"'Agreed,' said the Bishop.

"And the Rabbi returned to his home.

"When he arrived at his home, it was clear to him that he had sinned. Why didn't he tell the Bishop right then and there that he would not convert? What was there to think about? When the three days had passed, the Rabbi did not return to the Bishop. The Bishop sent guards for him. Still, Rabbi Amram would not heed the call. So the Bishop had him brought before him by force.

"'Cut out my tongue,' the Rabbi said, 'for I have answered you falsely. I will never leave my faith!'

"'No,' replied the Bishop. 'Your tongue did not speak falsely, therefore, your tongue will not be cut out. But your feet did not obey my command for you to appear before me, so it is your feet that will be cut off.'

"The order was given and the unfortunate Rabbi suffered the consequence. However, Rabbi Amram accepted this punishment for he had sinned. When Rosh Hashana came, he asked his students to carry him to the synagogue, and there he said a prayer...."

Here, Elkhanan interrupted himself. "I forgot which prayer he said. Oh, Father Felix, I'm becoming a gentile! I've forgotten the prayer! I have sinned more greatly than Rabbi Amram!"

"But no one will cut out your tongue and no one will cut off your feet," the old man said softly and smiled at the boy. "And no one will force you to convert."

"But I have sinned! I have thought much about Rabbi Amram when his ship came into the port of Mainz carrying his body. Remember? I told you about it.

"And now, I'm thinking about another story. Now, I don't know if I'm Jewish or not. I want to go home!"

"We really do have to leave here," the old man responded suddenly, ignoring the child's words. "We will both go away far, far from here to a beautiful land. I have told you much about Italy, about Rome. We will go there together."

"Will we be passing by Mainz? Will I be able to see my mother and father?"

The old man pretended not to hear the child's questions.

"Yes, we will travel to Rome," he said.

✒ Brenner Pass

The horses stopped. Elkhanan stuck his eager little face out of the window and asked, "Where are we?"

"We are at Brenner Pass," Father Felix told him. "We'll rest here."

They had been traveling for two months. They were in no rush. They rested often, and if they came to a beautiful spot, they stayed for several days. Father Felix showed Elkhanan mountains and rivers, beautiful buildings and old churches. They rested in the churches. Father Felix praised Elkhanan to the monks, saying what a good boy he was and such an apt pupil!

All this while, Father Felix taught Elkhanan Latin, the language of the Church. He was teaching him the language spoken in Rome. He also told him stories of Christian saints.

Elkhanan was very pleased with the praise he received. He wanted Father Felix to teach him more so that when the monks asked him questions, he would know the answers. The monks were amazed at the child's knowledge. They shook their heads in wonderment and spoke among themselves: "Is this a child? What a mind! We have never seen such a child before!"

Elkhanan heard the praise and shyly lowered his eyes.

Father Felix patted his head and said, "Yes, he is a

very bright boy. Tell him something just once, and he remembers it!"

Elkhanan jumped out of the wagon. He turned around and around and back again. He had seen beautiful places, but now he stood in the magnificence of the high Brenner Mountains as they were bathed in the beams of light of the setting sun. The snow on the mountaintops was at first red, then rose, and then the colors changed quickly. Below was a black forest. White, red, black, green—so many colors, so many colors mixed together!

"How beautiful is God's world," Father Felix said.

Elkhanan thought, "This is what my father would have said." And all of a sudden he felt like crying. The surroundings were so breathtakingly beautiful, but he was beginning to feel so sad!

But he didn't have any time to dwell on his sadness. Near where they had stopped, people were running out of church. There was a big commotion. Everyone was led back into the church where they were served food. Elkhanan was very hungry and ate what was served. After that, they went to sleep.

They got up early the next morning. There were two mules waiting for them outside. Father Felix got on one, and a very tall monk got on the other. Father Felix lifted Elkhanan onto the mule with him. Very slowly, the mules climbed up the mountain. They came to a narrow road with many curves. They stopped at a little house, got off the mules, and con-

tinued on foot. The tall monk lifted Elkhanan onto his shoulders and they climbed higher on the mountain.

They came to a small church. From there, they could see so much of the world!

"We are at the border," Father Felix said. "From this side of the mountain you can see the beautiful country of Lombardy. We will go there and from there on to Rome."

"And when will we be in Mainz?" asked Elkhanan. There were tears in his eyes.

"Yes, we will get to Mainz, but first we will see many more beautiful things. After Rome, we will go to Mainz."

Elkhanan was silent. He thought that maybe Elijah, the prophet, would come at night and take him back to his home, but he didn't cry. The beautiful scenery distracted him.

ꞁ An Audience with the Pope

They journeyed six months before they reached Rome. Father Felix showed Elkhanan the beautiful sights and the ancient ruins.

The day came when Father Felix was overjoyed. Tomorrow, they would see the Pope! He had told Elkhanan so much about the Popes. More than all the others, he had told Elkhanan about the great Pope

Gregory VII, that he was more powerful than the Emperor. He told him that the current Pope was Urban II and that he was a great admirer of his predecessor, Pope Gregory VII. Tomorrow would be the best day in Father Felix's life! He was to see the Pope. And he would take Elkhanan with him, but Elkhanan must emulate him in everything that he did.

Elkhanan was uneasy. He wanted to see the Pope, but was torn by the thought that he would be committing a greater sin.

Now they stood before a great hall. Father Felix was holding Elkhanan by his hand. Two very large doors opened and Father Felix dropped to his knees. He pulled Elkhanan down. Both walked on their knees until they reached the throne. An old man in a long red cloak was sitting on the throne. Father Felix kissed the old man's hand and Elkhanan did the same. The old man smiled. Elkhanan heard Father Felix telling the Pope all about him. Good Father Felix heaped so much praise on him!

The Pope told Father Felix, "Take him to my good friend, Pierleone. It will be good for him there."

Father Felix whispered, "I have heard that Pierleone is descended from Jews. Perhaps—"

"My friend Pierleone was born a Christian. It was his father, Leo, the Pope's doctor, who converted to Christianity. Pierleone and his father have been our most loyal supporters."

The Pope and Father Felix whispered to each other

in Latin. Elkhanan could not understand it all. He was frightened. He was very anxious and worried about what was to happen to him.

✒ The Pierleone Palace

The next morning Father Felix dressed Elkhanan in fashionable new clothes and said, "We are now going to the richest person in all of Rome. His name is Pierleone and he is a good and wise man. It's possible that we will live there while we are here in Rome."

"How long will we be in Rome?" Elkhanan asked.

He did not get a response. Father Felix took his hand and they walked until they reached a palace. It was taller and grander than any other building and was made of marble. They walked up broad steps with columns on either side. At the entrance were two large stone lions. Father Felix and Elkhanan were led through many rooms until they came to the owner of the palace.

Pierleone lifted Elkhanan and put him on his lap. He asked him about his journey, about what he had seen, what he had experienced. Pierleone had a neatly trimmed rounded black beard with silver strands running through it.

"You're a bright little boy," said Pierleone. Father Felix beamed.

"You will remain here. Father Felix will be in one

room and you will have a room to yourself. You will get new clothes and new shoes. Tell me what else you want and I will get it for you."

Pierleone and Father Felix talked for a while. The host showed off his possessions and boasted about his influence in Rome. "If not for me," he said, "the Pope couldn't remain in Rome for one day. The noblemen in Rome support the Emperor and they are against the Pope. But I and my friends support the Pope."

From that day forward, Elkhanan lived in the palace. A servant dressed and undressed him. He wore the most expensive clothes and was surrounded by beautiful objects. He didn't see Father Felix as often as he had before. They were together for only two or three hours a day when he studied with his old friend. He spent the rest of the time with the Pierleone family. He ate at their table. Many people sat around the table, including the Pierleone children and many of their friends.

He often played with their youngest daughter. She was a little older than Elkhanan. Her name was Tropea.

⚘ A Discussion

One day, Elkhanan said to her, "You have such a strange name."

"No," she said, "*you* have a strange name. I can't

call you by such a long name. I have been told many times to call you Petrus."

"Don't call me Petrus, do you hear!"

"I *will* call you Petrus. If not, I won't play with you!"

"If you call me Petrus, I'll cry. Don't!"

"Only little girls cry. And you're a boy. Even I don't cry any more."

"But I am Jewish and Jews don't have that name. I have the name my father gave me."

"But my father said that you will live with us and that you will be my brother!"

"I don't want to be your brother!"

"Oh! You are bad! Don't you want to play with me?"

"Yes, I want to play with you, but I don't want to be your brother. Soon, I will be leaving here."

"Then I will cry. Don't you like it here?"

"Everything here is good, but I want to go home to my mother and father and study Torah. Do you know what I want to be when I grow up? I want to be a Rabbi!"

"I heard the grown-ups talking and they said you would grow up to be a cardinal or even a Pope!"

"Me? A Pope? I am a Jew. I haven't converted like your grandfather did!"

"You are so bad! My grandfather was never a Jew! I never heard that!"

"I know that this family has Jewish ancestors. Fa-

ther Felix himself told me! Your grandfather convert-
ed and my father is a Rabbi…so why are you crying?
Don't cry. I won't say it ever again. Please don't cry,
Tropea."

With tears rolling down her cheeks, the girl plead-
ed, "Please stay here. Stay here forever. Stay, Petrus."

🕊 A Letter

Three months had passed since Elkhanan came to
live at the Pierleone Palace. He was one of the family.
They called him Petrus and he answered to that
name. His friend Tropea was the one who started call-
ing him Petrus, and the others followed suit. The
only one who called him by his own name was Father
Felix.

And Father Felix was the only one whom Elkhanan
reminded that he wanted to go back to Mainz. But he
reminded him less frequently as time passed.

It was spring again. Wasn't this the season of Pass-
over? Was this the night of the first Seder? Elkhanan
was disquieted. He felt very uneasy. That night he
had a nightmare:

*He was a mute. He wanted to tell everyone that he
was Jewish but he couldn't say a word. He had to go
home to his mother and father. He traveled for
weeks, months and he still wasn't home. He wanted
to ask for directions, but he couldn't speak. He*

stopped people on the way and opened his mouth to make a sound. But nothing came out. He was mute. The people pitied him. They wanted to help him, but they didn't know what he wanted, so he went on his way. His feet hurt and his clothes were torn. He was hungry and thirsty and he didn't even know if he was going in the right direction. He wanted to say a prayer, but the words wouldn't come. He tried to say his prayers silently, but he had forgotten all the prayers he had once been taught. At first he was walking and now he was running. He didn't stop until he came to the end of the road. There was a deep, deep pit before him. A flowing brook was beneath it and all around it were boulders. Beyond this was a straight road with many trees. He stopped for a moment at the pit. Should he turn back? No, he must go home! He attempted to jump over the pit but fell into it. He kept on falling....

...and he awoke from the nightmare.

Frightened, he jumped out of bed. He noticed that there was a letter on his night table! It was a letter from Father Felix. He wondered why Father Felix was writing him a letter; he was right in the next room!

His hands shook as he opened the letter. It was written in Latin. Elkhanan had learned to read and write Latin very well. He read:

My dear child, my precious student, Elkhanan!
I find it very difficult to write this letter to you,

but I must. In time, you will understand and will not carry any hostility in your heart for my leaving you. I had to leave Rome. So commanded the Holy Father. I am returning to the church where I took care of you during your illness. You will remain here and be a true son to the fine and loving Pierleones. It is your destiny and I am sure that you will be very happy. You will be a great person and a great scholar. When you become a cardinal or perhaps a Pope you will be able to accomplish much more than if you did not have this opportunity. You are, after all, a very bright boy. So be content with your life; the life as Petrus Pierleone. I didn't say goodbye because I wanted to spare us the tears. I send you kisses and pray that my eyes will behold you when you rule over Rome.

Father Felix

🦅 Pierleone's Son

The letter rattled in Elkhanan's hands. He was shaking. There would be no going home. Yes, he did try to jump over the pit, but fell....

He stayed in bed a whole day, crying. He chased out the servant who had come to dress him. He wouldn't speak to Pierleone when he came to his room. He wouldn't answer the door when Tropea pleaded with him to get out of bed. Instead, he lay in bed motionless.

That evening he noticed unusual movements in the palace. He heard yelling and the sound of feet running in the hallway. Doors were banging and he heard cries. Suddenly, it became very, very quiet. Something had happened!

Elkhanan dressed himself. Very quietly he went from one room to another. He reached the great hall. Many candles were lit. Someone was lying there, covered with a black cloth. The whole Pierleone family was there, some sitting, others standing. The women wept softly. The men's faces were hardened and angry. What could have happened here?

Elkhanan moved without being noticed. He came upon his servant. The servant didn't wait for him to ask questions. She took him into a side room and told him what had happened:

In the last few weeks, the hostilities between the Pierleone family and the Frangipani family had been rekindled. The Pierleone family supported the Pope; the Frangipani family opposed the Pope. When the strongest family in Rome, the Pierleones, ran into their enemies and rivals, who were the second-strongest family in Rome, all hell broke loose. A few days before, one of the supporters of the Pierleones killed a member of the Frangipanis. A fierce and bloody battle ensued. Pierleone's oldest son, Albertus, led the fight. Early one morning, while Albertus was walking in a side street, a member of the Frangipani family attacked him with a knife and fatally wounded him.

Elkhanan walked back into the hall. Tropea noticed him. She took him by the hand and walked with him to her mother and father. Her mother put her arm around Elkhanan and kissed his head. Her tears wet his hair. Tropea's father lifted Elkhanan onto his lap. For the first time, Elkhanan felt like a true member of the Pierleone family.

The Pope Who Hid

The Pierleones were determined to get revenge for the death of their son, Albertus. They fought the Frangipani family in the streets. Both sides suffered many casualties.

The Frangipani family had the upper hand in the battle and since they were opposed to the Papacy, it did not bode well for the Pope. The Pope feared for his life and fled his residence. He escaped to the Pierleone Palace. There, he remained in hiding for a long time.

When Elkhanan had seen the Pope for the first time, Urban II was a formidable figure, a tower of strength as he sat on the throne in his red cloak in the big hall. He remembered how he and Father Felix approached him on their knees. The Pope had been so awesome! Now, Elkhanan saw him frequently and he was just the opposite. He was an old and frightened man. He compared the Pope to his "father" Pierleone. His "father" was self-confident, self assured, and

strong. Elkhanan pitied the Pope. He thought to himself: *when I am Pope, I'll show them—the kings and the Frangipanis!*

Elkhanan was ashamed of his thoughts. Was he really no longer Elkhanan? Was he now truly Petrus Pierleone?

Having met young Petrus before, Pope Urban II was good to him. He liked talking to the little boy and told him many stories about his role model, Pope Gregory VII. Pope Urban II wasn't as good as Father Felix, but he was more knowledgeable. The Pope also spoke about the Jews. And there was one thing that pleased Elkhanan very much: the Pope said that "the Jews are eternal; there will always be Jews in the world."

"Why do you force Jews to convert?" Elkhanan asked

"That's not true," the Pope answered. "True Christians would never do that. Only barbarians who think that they are Christians do that."

Elkhanan wanted to ask the Pope about himself, but he didn't know how. Instead he changed the subject and asked, "Is it true that Romulus surrounded Rome with a wall because he was afraid of the Jewish King David?"

"It's possible that it's true." He continued to tell the child that there are two eternal cities: Jerusalem and Rome. And he added that now Jerusalem must rescue Rome!

✀ On the Eve of Great Events

Elkhanan heard words he didn't understand, but he stored them in his memory and recalled them later.

The Pierleones recaptured Rome and the Pope was reinstated. With his full power restored, he made plans for a great event. There was constant discussion at the Pierleones' on the subject. They planned to go to war against the Moslems. The Christians wanted control of the holy city of Jerusalem. They hoped to accomplish this for the greater power of the Church.

From what he heard of the discussions, Elkhanan's understanding was that Jerusalem had to save Rome! The old Pope did everything in his power to stir up the Christians. They concocted stories that the Moslems did not permit Christians to visit their dead at cemeteries. The Pope went so far as to travel to the clergy on the other side of the Alps where there was a large Christian population. He called them together to get strong support for the Holy War. *They had to wrest control of the Holy Land from the Moslems!* During the trip, the Pope died. His successor continued the call to arms.

Another year passed. They were ready to go into battle. A large army had been recruited and was ready to save the Holy Land from the Moslems.

Petrus Pierleone knew everything that was going on. He was no longer a little boy. He was twelve years old. He understood more than many adults. No one

hid anything from him. Lately, though, he had noticed that they were being secretive. A few times when he walked into a room, the discussion suddenly stopped. He wondered what was going on.

He knew that the Pope received reports that they didn't want to discuss when he was in the room. What could be in those reports, he wondered. He asked his father, but his father did not respond.

Where could he find out? Maybe Tropea knew. Tropea would tell him. But Tropea said: "It's terrible, terrible." And she began to cry.

Elkanan was determined to find out about the "terrible" news.

𝒯 Alone at Night at the Lateran

He was thoroughly familiar with every room in the Lateran. He knew where all the documents and latest reports were kept. He also knew where the guards stood duty. He was determined to find the information he was looking for!

It was a warm summer evening. All was quiet. The streets were empty, and there was a little door that was slightly ajar at the Lateran. The huge doors were securely locked. The foolish guards sat and chatted with each other, telling each other stories and playing games. They didn't notice the boy as he made his way to the little door. He squeezed through the opening

and ran through the courtyard. He knew the way well. The shadows cast by the trees shielded him from view. He reached another door. Alas, it was locked! He walked sideways with his body pressed against the wall, and, yes! A window was open. Like a cat, he made his way along the stony wall until he reached the part of the wall that was smooth. He grasped a branch of the tree near the window and jumped through the narrow opening.

He was familiar with the room. He knew that he must open the door to the right and there he would find the documents. There were many closets. He went to open one. It was locked. He tried the next one. It was open! He found the documents that had recently arrived.

The moon provided him with good light. He found what he needed. He saw a report from the city of Worms. Bishop Adelbart of Worms had sent the report.

They attacked the Jews in their homes and slaughtered them. They looted the homes before they set them afire. When the Jews realized that they could not defend themselves, they committed suicide so as not to fall into the hands of the Crusaders.... The bishop tried to hide some of the Jews in his palace, but the Crusaders attacked the Palace. The Palace guards wouldn't defend the Jews. Some Jews took their own lives. Those who didn't were killed. More than 800 Jews died....

Elkhanan found another document, this one from Speyer.

Jewish blood flowed. There was looting and much, much worse! Terrible things! The Jews called out "Shema Yizrael!" (Hear, oh Israel). And the boy's lips mouthed the prayer: "Hear, oh Israel, the Lord, our God. The Lord is one."

There was still another report, one from Mainz.

ꙥ The Dead Jews of Mainz Numbered 1,014

With his eyes burning, Elkhanan read the document.

The Jews of Mainz were aware of what the Crusaders had done to the Jews in Worms and Speyer. Frightened, they brought gifts to the Bishop of Mainz, seeking his protection. The Bishop accepted the gifts and promised to help them. When the Crusaders reached Mainz, they found the gates locked. Guards stood on the walls with armed Jews beside them. For two days, the Crusaders attempted to break through without success. They tried to talk the people of Mainz into letting them pass through the gates with the promise that no harm would come to them, to no avail. No matter how fiercely the Crusaders fought, they could not break through.

However, on the third night, they succeeded. Christians secretly helped the Crusaders and be-

trayed the Jews. Since the Jews guarded the main gate, the crusaders went around the wall to two smaller side gates and were able to enter the city. The Jews were attacked from within. The state guards did not offer any assistance to the Jews. The Jews fought valiantly but they were outnumbered and did not have many weapons. They had been attacked from the rear. When the Jews realized that all was lost, some committed suicide; those remaining were slaughtered. One converted to Christianity in order to save his life. The day after, he had regrets, went into the synagogue and burned it down so that it wouldn't fall into the hands of the Crusaders. The fire spread and a part of the city burned down. Fifty-three distinguished Jewish leaders were protected by the Bishop, who had hidden them in the castle. But the Crusaders were aware of this and they surrounded the castle. The Bishop saw that saving the Jews was a lost cause, and he tried to persuade them to convert in order to remain alive. But when he made this suggestion, the leader attacked him vehemently. The Bishop's guards killed the attacker and the crusaders slaughtered the others.

Elkhanan read the long report that ended as follows:

A small number of Jews escaped. All others were killed. No one was left to bury the dead. The total dead numbered 1,014 men, women, and children. We buried them in nine large graves.

Elkhanan steeled himself to read the report to the very end. He noted that he didn't recognize the name of the Jewish leader. It was not his father's. The paper slipped out of his hands and he fell to the floor in a faint.

Two hours later he was found still lying on the floor in a stupor. When the guards realized who he was, they carried him to the Pierleone Palace.

🐦 Tropea, Sister Mine!

The first person Elkhanan saw when he opened his eyes was Tropea. He took her hand and whispered, "Tropea, sister mine!" and burst into tears. Tropea cried, too. Standing at the door, the servant watched them and wiped her moist eyes.

Petrus was in bed for a few days. He didn't cry; he was very cold. He didn't have the strength to get out of bed. The whole time, Tropea did not leave his side.

When he was able to leave his bed, he was called to appear before his "father."

Pierleone said to him, "Now there is nothing to hide from you. You know the whole truth. Now you know that you have no one to return to. You are my son. You will replace the son I have lost and I will replace the father you have lost. No one will ever find out your secret. Father Felix has disappeared. The Pope is dead, and, well, I will send the servant who

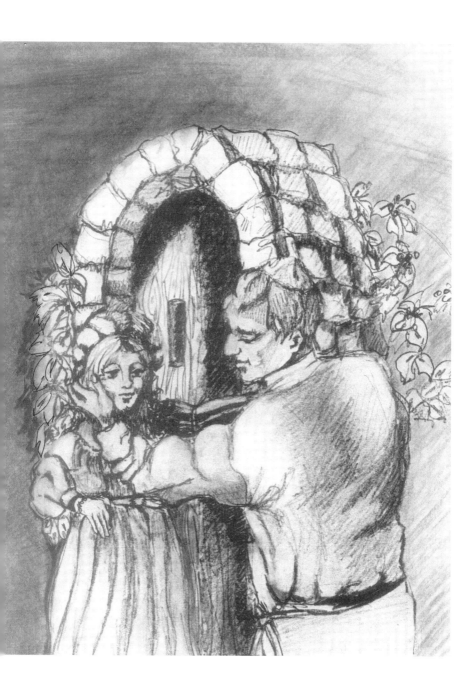

knows too much far away from here. Your future is that of Petrus Pierleone!"

Petrus stood up and went to his father and embraced him. Elkhanan thought, I would be dead now if I had not been taken out of Mainz. The one who is alive is Petrus Pierleone. He had the same thoughts that night in bed after the servant had left the room, but he had many other thoughts that night. Thoughts that made him blush. He was ashamed of himself: *Tropea, sister mine!*

The years flew by. Petrus was now eighteen years old and a great scholar. He had learned all he could in Rome and his father wanted to send him to France to study with Abelard and become a monk. He obeyed all of his father's wishes, but he really didn't want to leave and become a monk. He was in love with Tropea! He had grown up with her. They had played together as children. She had been there to console him in his most trying moments. She was always in his thoughts: *She is so beautiful!*

But he had to drive these thoughts from his mind. In the eyes of the world, she was his sister. He wondered if there were ways that he could stop being part of the Pierleone family. How could she stop being his sister? He could not fall asleep. His thoughts wouldn't leave him. He was well educated and very bright, but no plan came to him on how to remedy the situation. He knew that matches were being considered for her. Her father was in no rush to marry off

his daughter, even though she was almost twenty years old. He was waiting for a suitable match for her, someone important.

Soon thereafter, he found someone worthy of marrying into the Pierleone family. It was Roger, the young King of Sicily.

Tropea did not want to become a queen. She preferred...but no, he was her brother! She lay in her bed with thoughts of the following morning, when she must say goodbye to family and friends and go to Sicily to wed King Roger. She could not fall asleep on this last night in the home she loved, where she had spent all her life, where she had been so happy. It was a quiet spring night.

She got up and put on her robe. She walked into the garden on the wet grass. She walked as though in a dream. She looked up and saw someone sitting on a bench. In her heart, she knew who it was. The person sitting on the bench heard footsteps, but didn't lift his head. Tropea took his head in her hands and kissed him.

Petrus jumped up, drew Tropea to him, and kissed her passionately. He whispered softly and painfully, "Tropea, sister mine!"

Tropea pulled away from him and ran back to her room.

The next day she left for Sicily. And the day after that, Petrus left for France. A year later he was a monk in the famous Cluny monastery.

✍ The Cardinal of Trastevere

The career of Petrus Pierleone was phenomenal! Year after year, he was elevated in the hierarchy of the Catholic Church. This added to the prestige of the Pierleone name. Petrus was more knowledgeable and better educated than his peers. He was extraordinarily bright. He was an accomplished diplomat and was sent on important missions to various lands, but never had the occasion to go to Germany.

After traveling far and wide for several years, he returned to the Pierleone Palace.

There, he was welcomed as an honored guest, the elder Pierleone basking in his reflected glory. But Petrus came at a time when Rome was in turmoil. The Prefect of Rome had died. It was the Frangipani family who decided that the Prefect's son would be the successor to the post. But the Pierleones had intended that one of their relatives would be the Prefect. The Pope sided with the Pierleones. But the Frangipanis stirred up the population, saying that the Pope was taking away the rights of the citizens of Rome. They attacked the Pope while he was in church on the second day of the Greek Orthodox Easter. The Pope barely escaped with his life. Once again, a Pope sought refuge in the Pierleone Palace, but this time, the Pope had to accede to the wishes of the citizens. The Peirleones had lost this battle. The Frangipani choice of Prefect prevailed.

In order to assuage his old friends, the Pierleones, the Pope appointed Petrus a Cardinal. Petrus was the youngest Cardinal in the Church. His official title was "Cardinal of Trastevere." Trastevere was located in the area of Rome where there had been a "Jewish Street," the actual street where the previous generations of Pierleones had lived.

Young Petrus received an order from the Pope to go to Germany on an important mission. Petrus went with a heavy heart. When he reached Brenner Pass, he remembered his journey with Father Felix and thought: *"Now, I'm going home!"*

🦅 Just a Jew

The Cardinal rode in splendor with guards on either side of his carriage driven by four magnificent horses that kicked dust up onto the carriage.

It was the time in Germany when war raged between the dukes who sided with the Pope and those who opposed him and supported the King. The Cardinal came to help the supporters of the Pope. He addressed the noblemen and convinced them to join in the battle against the supporters of the King. Then the Cardinal set out for Regensberg. He surrounded himself with many guards. They needed to contend with those Knights along the way who still supported the King. The strongest among them was the "Knight

of Red Rock." The Cardinal was told that the Knight was coarse and mean and boasted that he would kill the Cardinal and hang his head on a spike at the front door of his castle.

Nonetheless, the Cardinal calmly entered the city of Regensberg. He was dressed in his broad violet cloak. The carriage was decorated in grand splendor and trumpets sounded loudly. Religious Christians fell to their knees. Suddenly, the carriage stopped. There was a commotion.

"What has happened?" the Cardinal asked.

"Someone threw himself under the feet of the horses and was almost trampled," the servant answered.

"Who is he?" the Cardinal asked.

"No one of importance; just a Jew," he was told.

"How do you know that he is a Jew?"

"He looks like a Jew. It's easy to recognize one."

"What does he want? Why did he throw himself under the horse's feet?"

"He wanted to stop the Cardinal's carriage. He has something to ask of the Holy Cardinal."

"But what?"

"He won't tell us. He will speak only to the Cardinal. It is what he yelled when we pulled him up."

"Bring him to me now!" the Cardinal ordered in a sharp tone.

Having bound the Jew's hands, the servants lifted him into the carriage.

The Jew was in shock; his clothes were torn and dirty. He could barely talk. He reached for the Cardinal's hand to kiss it, but the Cardinal didn't allow it.

The Cardinal waited until the Jew calmed down.

🜲 The Knight of Red Rock Castle

"Who are you?" the Cardinal asked.

"My name is Mesholem," the Jew answered.

"What is it you want?"

"I wish the good Cardinal to help me. Only you can help me in my great need."

"What misfortune has befallen you?"

"Help me from my enemy, the Knight of Red Rock."

"The Knight of Red Rock is an enemy of the Pope. Therefore, he is my enemy. And if he is your enemy, too, then we are friends."

The Jew's face lit up. He calmed down and felt more confident. He began to tell the Cardinal his plight:

"I have a daughter, Rebecca, my one and only daughter, beautiful and gifted. Everyone in Regensberg admires her. But for Jews, it is a disaster to have a beautiful daughter. The Knight of Red Rock was told of her beauty and sent his men to hide in a valley where she walked every Sabbath on her way to the synagogue. There she was abducted in broad daylight.

She was unable to fight them off and was taken to the Knight of Red Rock's castle. She is being held captive there."

"How old is your daughter?"

"Thirteen. I pleaded with the Knight of Red Rock to no avail. The Bishop of Regensberg interceded for me to no avail. The Knight of Red Rock said he was going to hold her until she was older, force her to convert, and then marry her...."

"If we cannot ransom her, maybe we can rescue her through force," the Cardinal thought aloud.

"He dared us to try to take her from him!"

"Why is he boasting? Why is he so sure it cannot be done?"

"Because his castle is a stronghold on high ground and in order to get to it, one must go on a narrow, dangerous road with many curves. He has many guards on the road. One of them can easily slay ten who charge the castle. How, then, can my daughter be rescued?"

"There is a saying in the Pierleone family: *When money won't help, the sword will. And if the sword won't help, a clever solution will.*"

The Jew was now totally at ease. So much so that he dared to say,"That sounds like a Jewish proverb."

The Cardinal's face became serious. It frightened the Jew. He grabbed the Cardinal's hand and kissed it. The carriage stopped in front of a big church.

"Admit the Jew to me any time he wishes," ordered the Cardinal.

✒ The Clever Solution

The Jew came to the Cardinal that night and told him that the Knight of Red Rock has his servants blow a horn, giving three long blasts, which signaled the guards to let the visitors pass and open the door to the castle.

Three days later, the Cardinal had formulated a plan. With only a few servants to accompany him, he rode toward the Knight's castle. No one stopped him. So he tried his plan for a second time. This time, as the carriage got closer to the castle, the Knight and his armed guards, who had been hiding behind trees, attacked the disarmed servants and attempted to abduct the Cardinal. This was what the Cardinal had anticipated.

Suddenly, the Cardinal's armed guards appeared as though out of nowhere and surrounded the Knight and his men. The enemy was unable to resist. The horn was wrested from one of the captives. The Knight was bound and thrown into the carriage. From the distance, the Knight's guards could see their master in the carriage and heard the three long blasts that signaled them to let visitors pass unharmed. The doors of the castle were opened wide. It was not until the Cardinal was inside the castle that the Knight's men realized their error. By then it was too late. The Cardinal's guards had secured the castle.

The Knight of Red Rock arrived at his castle a pris-

oner, bound and humiliated. He was silent and kept his eyes to the ground.

The Cardinal's men searched for the Jewish girl but could not find her. So the Cardinal ordered his men to bring the Knight before him.

"Where is the girl?" he asked.

"You won't find her. If I can't have her, no one else will! Let her die of hunger in her chamber! I won't show you where she is and you will not be able to find her," answered the Knight.

The Cardinal ordered his men not to give the Knight any food until he told where the girl was being kept.

On the second day of his captivity, the Knight said he would reveal where the girl was being hidden. With guards on either side of him, he led the way. He led them higher and higher up to the highest tower, the Cardinal and his men following. Then suddenly, the Knight tore himself away from the guards and jumped through an opening in the tower wall and fell to his death.

⤳ Rebecca and the Pigeons

They had to find the girl! Impossible! They tore through walls, searched the cellar, and searched the many underground tunnels. She could not be found. Where could she be?

Either the Knight's guards did not know or they

weren't telling. The Cardinal was worried. He walked into the garden, surveying the walls of the castle from top to bottom. High, high up, he noticed that pigeons were circling a window. Two doves perched on the window ledge and then disappeared from view. No doubt they must have flown inside, thought the Cardinal. And as he watched the pigeons, the girl suddenly appeared...Rebecca!

Excited, he called his servants and showed them where the pigeons were circling the tower. "Find the entrance to that chamber," he ordered. His servants tried one way and then another and another, but were unable to get to the chamber where Rebecca was being held captive.

The Cardinal thought for a moment and then ordered his men to catch one of the pigeons. They caught one of pigeons and gave it to the Cardinal, who wrote a note and attached it to the bird. He let it go and away the bird flew, high up to the roof where it disappeared. Soon, the bird returned with a message: "You can only get to my chamber from the roof. One must look very carefully to find the door."

It wasn't until after two hours of searching that the door to the chamber was found and broken into. They found the girl holding two of the pigeons close to her. Rebecca could barely keep from falling. Tears of joy filled her eyes. She didn't talk to anyone but to her pigeons: "Dear little birds, I have no food to give you." Rebecca had long black hair and blue-gray eyes.

The Cardinal took the girl back to her overjoyed fa-

ther in Regensberg. With a strong, proud voice, she said to the Cardinal, "They couldn't break me under torture, nor with kindness."

The Cardinal said, "They couldn't get to me through torture, but I did succumb to kindness."

Rebecca looked at her rescuer quizzically and didn't understand the meaning behind his words.

🦅 Pierleone the Elder Dies

The Cardinal of Trastevere carried out his mission in Germany successfully.

The supporters of the Pope were victorious and the Cardinal returned to Rome a hero. The Pope heaped many honors upon him. But the old Pierleone was not able to enjoy these honors. He lay in bed quite ill and near death. He had not yet accomplished his goal. Petrus was not yet Pope! He wasn't going to live to see it. But it must happen! When the Pope came to visit the deathbed of his good friend, he had to promise that Petrus, the oldest son of the Pierleone family, would follow the Pope in the Vatican. With this, the elder Pierleone peacefully closed his eyes forever.

The Pope kept his word. He gathered the Cardinals together and they mounted a campaign to publicize the virtues of the Cardinal of Trastevere. They were sure that they had a majority in his favor. The Frangipani family was aware of this and waited until the death of Pope Urban II to act.

🐦 The Legal and Illegal Pope

As soon as the Pope died, a small group of Cardinals got together without the knowledge of the others and proclaimed the new Pope to be Cardinal Gregorius and called him Pope Innocent II. The majority of the Cardinals became aware of this a couple of hours later and quickly proclaimed the new Pope according to the laws of the Church. The majority of Cardinals, the nobles, and the citizens of Rome unanimously elected Petrus Pierleone, Cardinal of Trastevere, the legal Pope. His name: Anacletus II.

The rightful Pope, Anacletus II, occupied the Lateran and Rome. The illegal Pope stayed in the fortress of the Frangipanis for a short while and then fled to France.

Anacletus II prepared to celebrate the official ceremony of a Pope's installation. He thought, "Two Popes—Jacob and Esau—and so far Jacob is victorious. Will the victory last?"

Tropea had sent her congratulations. It made him sad. His heart was heavy and he was reminded of the story of Rabbi Amram who sinned and asked that his tongue be cut out. And he thought of Rebecca with the blue-gray eyes who had been stronger than he. "Holy Father," he prayed to himself.

The ceremony was about to begin.

Part Two

🦅 Father and Daughter

It was windy and raining. A middle-aged Jew and his fifteen-year-old daughter stood by the road which led to Rome. Near them lay a donkey. They struggled to raise the donkey, but nothing they tried helped. The donkey didn't even reach for the bundle of grass that the girl offered him. Tears ran down the cheeks of the girl with the blue-gray eyes, and she was very cold. She felt sorry for the donkey.

"Leave the donkey and let's walk the rest of the way to Rome. It isn't far," the father said to the girl.

"How can we leave the donkey? He has served us well," the girl said and didn't move from the spot.

"You can see that we cannot help him and we cannot carry him," the father said.

"Let's wait here for a while. Maybe a peasant will come by and take him and give him medication to make him well," the daughter suggested.

"No one will want him. Someone will clobber and skin him for the fur, and perhaps not even that. His fur isn't worth anything."

"How can you talk like that?" complained the daughter. She bent down and petted the donkey.

"Don't be childish!" scolded the father. "If we stay here, we will die of hunger and cold. Just remember what we've gone through since we left Regensberg.

All because of you, robbers stole the diamond I had cleverly sewn into my jacket. And why did I have to leave Regensberg? All because of you!"

The daughter did not respond. Big tears welled up in her eyes and spilled down her cheeks. Her dress was muddied and her shawl had holes in it so that it hardly kept her warm. She was wet through and through and was shivering.

Her father was sorry for being sharp with her and softened his tone. "Come, Rebecca!" he said gently. "You are my only true diamond. You know that everything I do, I do for you. But it's hard for a Jew to have a beautiful daughter. It started with the Knight of Red Rock and now I see how men leer at you. I have not been able to get a match for you in marriage because of the foolish tongues of the gossips. If only your mother hadn't died. If only we hadn't taken it upon ourselves to leave Regensberg. I am the one to blame. Don't be such a child. Stop your crying. Come, let's go."

The girl bent down to pet the donkey one more time and then followed her father.

At the Gates of Rome

They were nearing Rome, exhausted from the long journey, but it didn't pay to stop since they were so close to the border. The father didn't want to enter

the city as a hungry beggar so he said to his daughter, "Do you know how Rome was built? It was built because Jews had sinned.

"When King Solomon married Pharaoh's daughter, an angel came down from heaven and made a cross in the middle of the ocean. An island completely covered by a forest arose from the middle of the cross.

"And when Jeroboam, son of Nabat, placed two golden calves in the cities of Dan and Beit El, people went there for the first time and put up the first two tents.

"And when Elijah the Prophet was hiding from Jezebel, the first King of Rome was crowned.

"Rome started its first war to capture the surrounding countries when Menasha, the first King of Judea ordered that idols be placed in the Temple and sent his men to murder the Prophet Isaiah.

"So it is that Rome is the land of Esau, Jacob's eternal enemy."

"But, Father, I remember you told me that the Messiah is sitting at the entrance to Rome waiting for his leg wounds to heal. But whenever he unwraps the bandages to look, the wounds are not healed, and he has to wrap them again and again each time. You said that he sits at the gates of Rome as a beggar…just like us," Rebecca ended with a sad smile.

The father's body quivered. He was still unaccustomed to having gone from a prosperous merchant of Regensberg to a poor beggar.

They didn't see the beggar at the gates of Rome wrapping and unwrapping his leg wounds. It was late in the evening and there were no people in the streets. They saw only two soldiers armed with swords and lances who blocked their path. The soldiers were drunk and were laughingly jostling each other.

"Stop," the soldiers shouted. "Don't you see the cross?"

"We're Jews," Mesholem answered.

"And is the beautiful girl your daughter?" asked the soldier.

"You're drunk, Antonio! Do you find a dirty beggar girl beautiful?" the second soldier asked laughingly.

"It's better to be a drunk rather than be a religious Christian when a Jew has been elected Pope."

"Why should you care? We're getting plenty free wine. Today, at the Pierleone Palace, we can get as much wine as we want and we don't have to pay for it. Long live the Pierleones!"

Listening to the soldiers, Mesholem and his daughter were puzzled by the strange conversation. They walked past the soldiers into Rome without incident.

Jew Street

Mesholem and his daughter, Rebecca, went directly to the house of Rabbi Solomon ben Abraham, the Chief Rabbi of Rome. He was called "the Prince."

The Rabbi was very busy preparing for a ceremony. The sexton told Mesholem that a big celebration was to take place the next day for the coronation of the new Pope, Anacletus II. Jews were required to participate in the ceremony. They had already decorated the "Jew Bridge" over the Tiber with flowers and rugs running the length of the bridge. Jews were forced, as usual, to decorate the Triumphal Arch of Titus, who had conquered Jerusalem and destroyed the Holy Temple.

"Tomorrow is a dangerous day for the Jews," the sexton told them. "Who knows what is in store for us? Nevertheless, Jews must appear to greet the new Pope. The Christians laugh and throw stones at us, *but appear, we must!*"

After a while, Mesholem felt rested and when the Rabbi could hear him out, he told how his daughter had been kidnapped by the Knight of Red Rock and how the Cardinal rescued her.

"Are you saying that the Cardinal rescued your daughter?" the Rabbi asked, to be sure he had heard correctly.

"Yes," confirmed Mesholem. "Yes, the Cardinal of Trastevere."

"The Cardinal of Trastevere is the newly elected Pope, whose coronation ceremony is scheduled tomorrow!" the Rabbi said with emphasis. "We Jews of Rome are required to give him our Torah as a gift! I had heard from the lips of my own grandfather,

Yekhiel, that he knew the Pope's grandfather, Barukh Pierleone, very well. Barukh's son, Leo, was a doctor to Pope Leo IX, and converted to Catholicism. This newly elected Pope is a member of the Pierleone family! Who understands God's ways?"

"I am a stranger here and have come for help. I thank you for your kindness and friendliness," said Mesholem. "But frankly, we have a Jewish saying in Germany: *Every apostate is like the wicked Haman.*"

"Well, the Pierleone family never moved out of Jew Street," said Rabbi Solomon. "They live among the Jews of Trastevere and never denied their Jewish ancestry. We are proud of this Pope...and apprehensive."

The Prince promised to help Mesholem and asked the sexton to provide a place for him and his daughter to stay.

⁊ The Rabbi and the Torah

The City of Rome had become impoverished from the war between the Popes and the Emperor of Germany. But now the great day of the celebration of a lifetime for Catholics the world over had arrived. Rome was to get a new leader, and in his honor, the city was adorned in great splendor, just as it had been in the past. Flags fluttered in the wind. Flowers lined the streets, and carpets were laid where the procession

was to pass. Choirs from the churches sang hymns; church bells rang out, carrying the sound far and wide.

Old customs determined the protocol of this special day of celebration. Jews had to gather in a specified place. They recited prayers and sang psalms. When the procession reached the place where the Jews had gathered, the Rabbi had to step forward, holding the Torah with the mantle embroidered with gold and covered with a veil. The Rabbi had to then remove the veil and hand the Torah to the Pope.

The Pope was carried on a sedan by his most loyal supporters. Above him was a canopy. He was wearing a long red cloak. On his head was a diamond tiara. The Pope then took the Torah from the Rabbi. Was the Torah so heavy as to cause the Pope's hands to tremble? Or was the young Pope reminded of something?

Now the Pope removed the mantle and unwound the scroll to a specific passage. He asked that the passage be translated for him. This is the custom.

It just so happened that the place at which the scroll was unwound was the Ten Commandments. The Rabbi was to read the following to the young Pope:

"Honor your father and your mother so that your days on earth will be extended."

The Pope listened to the Rabbi's words and answered according to the custom:

"We take the Torah that God has given you, Jew, but we do not accept your translation. Once you were God's chosen people but now you are His enemy. You have no hope of the coming of the Messiah for he has already come and you have rejected him!"

The Pope's voice seemed to quiver as he said these words and handed the Torah to the Cardinal who was standing nearest him. The Pope had to then to put his foot on the Rabbi's forehead. This was part of the ceremony. The Rabbi waited. Everyone around the sedan chair waited.

✒ The Voice of a Girl is Heard

There was a long pause. Usually, at the point when the Pope put his foot on the Rabbi's forehead, the crowd would begin to shout epithets and insults at the Jews and throw stones at them. Wild and "jolly" spectators would come forth as part of the ceremony. This could culminate in a bloody massacre.

But the Pope waited. He looked around. He saw a girl with large luminous eyes among the crowd of Jews in the plaza. The eyes stared at him. Where had he seen those eyes before?

Suddenly, all was quiet, and from the crowd he heard a voice call out loudly. It was the girl and she was shouting, "He's the one! It is he!"

Someone in the crowd covered her mouth with his hand.

And suddenly, the Pope remembered. She was the girl of Red Rock. She was the one who had told him that they couldn't persuade her to convert, either by force or by kindness.

"Holy Father," the Cardinal whispered in his ear, "put your right foot on the Rabbi's forehead!"

And the Pope spoke up: "Go, Jew. No harm will come to you. You are God's eternal witness and we will tolerate you even though you have sinned."

The crowd was heard to mumble to each other, "Something new has occurred, something so different!"

The Pope signaled for the procession to continue on its way. The part of the ceremony forced upon the Jews was over.

Many in the crowd were disgruntled, for after all, they had come prepared to hurl stones on the perfidious Jews. They dropped their stones. In the stillness of the crowd, a voice rang out:

"After the procession, everyone is invited to the Pierleones for wine—as much as you want!"

The mood of the crowd became jubilant. They shouted, "Wine, wine! Long lived the Pierleones!"

One could see the angry expressions on the faces of the Cardinals. A tall, thin monk with an emaciated face spat on the ground and went into a side street. His name was Bernard of Clairvaux. He had come from France to attend the ceremony.

✍ Two Expressions

After the ceremony, the elderly Cardinal Petrus of Partus remained with the Pope. He appealed to him:

"Holy Father! We must not forget that we are at war with a strong enemy and only in Rome are we victorious. The enemy will take all measures possible to defeat us—"

"And the enemy will always call to everyone's attention that the Pope is a descendant of Jews. Isn't that what you really wanted to say, my dear old friend?" interrupted the young Pope with a smile.

"They will also say," said the elderly Cardinal, "that once a Jew, always a Jew! And they will constantly remind the people that this Pope would not insult the Rabbi and that he gives freedoms to the Jews."

"Have I done anything or said anything that is not consistent with the Holy Church?"

"Though I am old and have seen much in the Pope's residences, it isn't necessary for me to teach the Holy Father. But I will say this: that we must not initiate any innovations, especially where it concerns the Jews; not even the tiniest concession."

The Pope did not respond. He was deep in thought.

Suddenly, the Cardinal asked, "Did everyone hear what the girl said?" but he didn't wait for an answer and continued, "I didn't hear what she said. Shall I make inquiries?"

"No, it isn't necessary. I really want to rest now."

The old Cardinal left. That night the Cardinal received an angry, hostile guest. It was the monk, Bernard of Clairvaux. He said:

"I have decided to leave Rome. I'm going to Pisa, to Genoa. I must get to my Pope, who had to flee from the Jew who stole the throne. I will do whatever it takes to serve my Pope!"

Cardinal Petrus of Partus tried to calm Bernard. "You already knew that Pope Anacletus II was descended from Jews. You also know that the Papacy has never before had such a brilliant and capable Pope on the throne."

"Yes," answered Bernard, "the Pope is descended from Jews. The Apostles were descendants of Jews. Christ himself was a Jew on earth. All of them were Jews, but this Pope has remained a Jew!"

"That's foolish talk," said Cardinal Petrus of Partus impatiently.

"You know exactly what I'm talking about. You, yourself, are not pleased with his conduct. You saw for yourself how he spoke to the Rabbi, how he did not follow the customary protocol of the ceremony. I swear to you that there is a secret bond between the Jews and the Pope! They give him secret signals. I had heard a voice among the Jews. And when the Pope heard that voice, he didn't follow through with the protocol, our old custom. No! He is not my Pope!"

"Stay awhile in Rome. Look around. It will be to your advantage. I don't want you to be my enemy," said the Cardinal to the angry monk.

"Aha! The Pierleones are bribing the public with wine! I want to change their attitude and I don't need wine to do it!" said the monk.

"Well, go wherever you want!" said the Cardinal.

"Why is it that you aren't stopping me? You said yourself that I can be a formidable enemy," said the monk, without moving from where he stood.

"I will do you no harm. If what you want is to desert the Holy Father and serve the intrigues and battles of his enemy, you are free to go."

"Just as I do not wish to serve the devil, so I do not wish to serve the Jew you have placed on the throne of the Papacy," yelled the monk and stormed out.

҂ "We Do Not Want the Jew!"

The next day, the Cardinal Petrus of Partus summoned two of his most trusted servants and bade them to find the Jewish girl who had called out in the crowd during the ceremony. They went to the Jews with whom they were acquainted to find out. The Cardinal also issued an order to detain the monk, Bernard of Clairvaux.

Neither order was carried out. No one knew who the girl was and the monk had already left Rome.

Many unsettling matters came to the Cardinal's attention, and his preoccupation with these issues allowed him no time to follow up on the orders he had given his servants.

The issue of the illegal Pope turned out to be more serious than he had thought. The situation in Rome was secure. The authority of the majority of the Cardinals and the Pierleone wine and money kept the people loyal and content. But every day, hundreds of letters were received at the Lateran. They arrived by special messengers and all were short, carrying the same message:

"We do not want the Jew!"

It was clear that the letters were not mere coincidence. The illegal Pope was working very hard and had succeeded in winning over the majority of the Bishops.

The Cardinal winced painfully as he read the letters, but the young Pope only smiled.

Pope Anacletus II hoped to succeed in winning over the Emperor of Germany. He had sent envoys with messages to no avail. The Emperor did not wish to give his support to the Pope. He had his own agenda.

The only friend to the Pope who had a large army was the German leader, Roger, whose wife's name was Tropea. Once, when the Pope's situation was very precarious and dangerous, he received a letter from Tropea.

✒ A Letter from His Sister

The Pope held the letter from Tropea in his hands. It had been so long since he had heard from her! He remembered how good she had been to him when he first arrived at the Pierleone Palace. *If not for Tropea,* he thought, *I would probably have not become a member of the family. And if I were not a Pierleone, I would not have become Pope.*

He remembered their secret parting on that spring night in the garden. He thought *If Tropea had not left the next day to be married, I would not have become a monk and if I hadn't become a monk, I would not be the Pope now.*

He began to read the letter:

Petrus, my brother!

When you became Pope, I sent you a greeting. I wanted to write you a long letter, but I couldn't. I was so proud of you, but very sad. I didn't know why. Now, many things have become clear to me: we are both prisoners.

I don't want to talk about myself. It's true I'm a prisoner in a cage, albeit a golden cage. I pass my days doing what I must do, not what I want to do. My husband has been good to me ever since I left my father's house. But he doesn't understand me and I don't understand him. He is a courageous warrior, but I perceive him to be a child and at times a wild

barbarian. This is the first time I am interested in his plans because he can help you. He will help you and protect you! But he wants to be compensated for his efforts. He wants the Pope to crown him King of Sicily. Let him have it. I don't need to be queen; it will be very difficult for me to get to Rome. I am, after all, a prisoner.

I am thinking that perhaps you too, are a prisoner. Ever since that foolish woman kidnapped you from your parents' home, you have been a prisoner. Are you living the life you want to live? Perhaps you have never been happy. Nevertheless, things went well for you. You didn't wear the black cloak of a monk for very long. You wore the violet cloak of a Cardinal at a very young age and now we will see you in the splendid, bright red cloak of the Pope. I have the feeling that under the red cloak beats the heart of a young prisoner; a prisoner that wants to be free.

I know that I shouldn't be writing this to you, but I know that when I see you I will not be able to say the things I want to say to you and I must speak my heart. My trusted servant will deliver this and no one else will see it.

You once told me a story about a holy man who begged to have his tongue cut out because he had sinned. They cut off his feet instead. Do you remember that story? We two are neither holy nor strong, so they bound our legs. Is that not true?

I don't want an answer. I just want a sign that you aren't angry that I wrote this letter. My heartfelt best wishes go out to you.

—Tropea, your sister

🐦 Drawn to His Roots

The Pope became very uneasy after reading the letter from Tropea. He forgot all the matters of urgency that he needed to deal with and thought *Am I really a prisoner? I, the Pope?*

He wondered if he should summon the Rabbi and have a talk with him. *Can I do that,* he wondered? *Yes, I can! But I must have my trusted Cardinal Petrus of Partus present...or perhaps another Cardinal? If no one is present, they will become suspicious and I'll make new enemies. And what if I want to find the graves of my father and mother? Can I? How? Travel there? Ask questions? No, that would cause suspicion. People will think: "Why is the Pope visiting the graves of a woman and a Rabbi who lost their lives in the Crusades so long ago?"*

And what if I walked to Jew Street to find the girl with the large blue-gray eyes?

Can I do that?

Who says I am a prisoner? Whose prisoner? I can do what I want! I will!

And the Pope made a decision. He ordered that he be taken to Jew Street.

~86~

It was a weekday, and the Pope's visit caused panic in the Jewish section. They never thought that this could or would ever happen. They rushed to the Rabbi to tell him that the Pope had already crossed Jew Bridge and would arrive momentarily.

"What does he want from us?" frightened Jews asked one another. "Does he want to help or harm us? It is unheard of to have a Pope on Jew Street."

The Rabbi didn't know what to do! He took a Torah in his arms and went to stand in his doorway, ready to greet the Pope. Anxious and frightened faces peered out behind shuttered windows.

As soon as the Pope crossed Jew Bridge, he felt he was doing something he shouldn't, that there was no sense to it. What was his reason for coming here? What did he hope to accomplish? He was embarrassed by the fear he saw on the faces of the Jews and felt shame as he saw the Rabbi in the doorway holding the Torah. These may have been his thoughts, but those who looked upon him saw only a composed and calm Pope seated on a sedan with a smile on his face. He was accustomed to seeing people kneel before him, and he was accustomed to making the sign of the cross to those who knelt before him. Lest he inadvertently make the sign of the cross from habit, he folded his arms across his chest.

He was reminded of a story about a son who left his home and wandered for years in strange places only to return to his father's home. He smiled, but he was thinking:

It isn't possible for this wayward son to return to the home of his father. Not in this fine chariot and not with such an entourage; and not as the ruler of his brothers. Not like this!

One of the Cardinals in the entourage whispered to another Cardinal so that the Pope could overhear him, *"This is bad. He is being drawn back to his roots!"*

When the sedan reached the end of Jew Street, it turned and returned to the Lateran.

⚜ In the Synagogue

The Pope was indeed drawn to his roots. This made him more disquieted and uneasy than ever. The day was nearing when Roger was to be crowned King of Sicily. Tropea would be at the ceremony. The Pope anxiously awaited her arrival. But she didn't stay long in Rome and stayed in the Pierleone Palace for only a few days. He saw her only once and that was at the ceremony. He never had the opportunity to talk to her. And only when he blessed her was he able to whisper to her, *"Tropea, Sister mine!"* And Tropea, pleased and grateful, bowed her head.

After Tropea had gone, the Pope became more uneasy and disquieted. He thought: *There is only one person in the world that I am close to, and that person is in another cage.*

The Pope had a strong yearning to be with Jews. But how could he accomplish this, he wondered? There was no way that he could repeat the foolishness of going to Jew Street. But his desire became stronger as time passed!

He took the clothing of one of the servants at the Pierleone Palace and disguised himself. One autumn evening he set out to cross Jew Bridge and enter Jew Street.

An old woman stopped him, saying, "Sir, I have juicy grapes, wonderful grapes. Not expensive! If you will only buy these delicious grapes. If you don't want the grapes, then let me tell you your fortune."

"For shame, old woman!" said a passerby. "The Holiday is almost here, and you're still working!"

"I need to work. I need the money to prepare for the Holiday," replied the old woman.

The disguised Pope did not buy the grapes. He saw many Jews dressed in holiday clothing on their way to the synagogue. He followed. When they reached the synagogue he thought, *Shall I go in?*

ꙮ Stories Heard Long Ago

And the wayward son entered the synagogue. The synagogue was brightly lit and packed with worshippers, but all was quiet. No one made a sound. The men were standing, wrapped in their prayer shawls. It

was as though he were seeing a forest of proud white trees. Several men began to whisper something. It was as though their words fluttered through the branches like a soft breeze. The others waited. Some late arrivals quietly found seats and quickly wrapped themselves in their prayer shawls, their expressions calm but serious. Their eyes sparkled with faith and assurance. The old Rabbi ascended the platform where the Torah would be read.

The old Rabbi told the congregation how this Holy Day of Yom Kippur was observed in the Temple of biblical days. He told how the High Priest prepared to enter the holiest part of the Temple, the Holy of Holies, where no one else was permitted. The High Priest himself was permitted to enter only one day a year, on Yom Kippur.

The Rabbi then told how after the destruction of the Temple, Rabbi Yokhanan ben Zakai, the leader of the Jewish people, went with one of his students to where the Temple had once stood. His student bemoaned the destruction of the Temple and said, "Woe is us! This holy place has been destroyed; this place where we received forgiveness. Where and how will we now be able to seek forgiveness?"

Rabbi Yokhanan ben Zakai replied, "Don't let it worry you. We have a better means to find forgiveness for our sins—to do good works. God says, 'I want goodness, not sacrifices!'"

The wayward son didn't understand anything fur-

ther that the Rabbi said. Either he had never heard those words before, or if he did, he had forgotten them. Suddenly, he began to shiver. The Rabbi was telling the story of Rabbi Amram of Mainz, the one who had had his feet cut off. How the Holy Rabbi asked his students to carry him to the synagogue so that he could praise God.

A stranger who was not wearing a prayer shawl was standing near the Rabbi. He was wiping his moist eyes. He appeared to be a healthy handsome man. In his mind, he was once again the five-year-old child Elkhanan sitting on the old housekeeper Golda's lap while she told him the story and lovingly patted his head.

🦢 On the Night of Kol Nidre

On the eve of Yom Kippur, the Rabbi told of the troubles and disasters that had befallen the Jews of Mainz, Worms, and other German cities. Refugees from those cities came to Rome and brought with them their beautiful melodies that were to be chanted on the eve of this Holy Holiday. It is the beautiful chant of Kol Nidre. The Rabbi wanted the Jews of Rome to incorporate the chant in their service, so he called upon one of the refugees, Mesholem, the cantor of Regensberg. He asked some of the youths from Germany to accompany the cantor.

Immediately after the Rabbi's speech, the choir began to chant the beautiful melody. It rang out in the brightly lit synagogue. And in the hearts and minds of the worshippers were thoughts of how hard it is to be a Jew. "But it is good; it is uplifting. If one loses his life because he is Jewish, so be it. We will never give up our faith and beliefs and our ancient heritage."

"How worthless I am," thought the disguised Pope. "I must return to my faith; to my roots!" He stood deep in thought all the while, until the worshippers began to leave the synagogue. He left, too, but stood outside the synagogue, observing the Jews.

One of the last to leave was Mesholem of Regensberg. With him was a young man, to whom he said, "Let's wait for Rebecca, who has been sitting in the women's section. She is a good daughter, a dear soul."

Rebecca soon appeared and started to talk excitedly about the new Kol Nidre chant that had captivated and mesmerized all the Jews of Rome.

"Well, we didn't come to Rome for nothing," she said as the three started walking away. "It's true we didn't see the beggar unwrapping his leg wounds at the gates to Rome, but we did see the young Pope, and we learned the beautiful Kol Nidre chant."

"That's odd talk, my daughter. Why are you mixing together the Kol Nidre chant and the young Pope?" said the father.

⚡ "That is He!"

"We didn't have to be the last to leave," said Mesholem. "The streets are empty."

"What are you afraid of?" asked Rebecca. She noticed that someone was following them. "There are two men against the one man stalking us."

"When there is a stalker in the street late at night, I am very much concerned."

"Let's go quickly," said the young man uneasily.

"No," said Rebecca, "let's stop so the stranger can catch up to us and we'll ask him what he wants." She stopped short and turned to face the stranger.

The stranger stopped also and hid in the shadow of a building.

"Come here, stranger, and tell us what you want," Rebecca called out.

"Are you out of your mind?" Mesholem whispered to his daughter.

The stranger approached and said, "I am a stranger. I'm not Jewish. I was in the synagogue and heard the beautiful chant. I would like to learn it. I would like to learn more of the chants and more stories like the one the Rabbi told."

"But what do you want of us?" interrupted Mesholem.

"Take me to your home," said the stranger. "Teach me, tell me about all things Jewish. I want to convert."

"It's late at night. Be on your way, stranger. If you want to convert, go to the Rabbi. We are also strangers here, and we don't want to get involved in such things," said Mesholem, thinking that the stranger must be out of his mind.

But the stranger did not move. He didn't take his eyes off Rebecca, who was bathed in moonlight. Her hair was covered by a white satin kerchief that made her look pale and taller than she actually was. Her blue-gray eyes looked dark and her long lashes cast a shadow on her cheeks. She was silent as she calmly studied the stranger.

After a short silence, the stranger repeated his request to be taken to their home. "I have nowhere else to go. I want to go with you and stay at your home."

Suddenly, Rebecca's eyes opened wide in fear and astonishment. She could not control her impulse to scream out loudly, *"It is he!"*

"Who is *he?*" asked the father, frightened by his daughter's outcry.

"It's he, it's he, the Cardinal of Trastevere and now the—" she began to shout, but Mesholem covered his daughter's mouth before she could finish her sentence. The stranger began to run from them as fast as he could, as though he were a robber being chased by police.

The moon shone brightly on Jew Street. All was quiet. Only the barking of dogs could be heard in the distance.

⚱ Under the Arch of Titus

It wasn't until he was far from Jew Street that the wayward son stopped. He was bathed in perspiration. He thought he must be ill and remembered the time he was in the forest and had climbed a tree to conceal himself from his pursuers, and how dogs had jumped up and down on the tree trunk beneath his hiding place. But, he wondered, why was he running now? No one was chasing him. From whom was he running? Why did he run from Rebecca?

When he went to Jew Street, he was hoping to find her. And then when he did, why did he run from her? He knew why. It was the fear he saw in her eyes! Why was she so frightened of him? What could he do to dispel that fear? Aimlessly, he wandered through the streets of Rome. He reached the Triumphal Arch of Titus and stopped beneath it. The moon lighted the Arch. Figures of Jews being led into slavery were carved into the stone. The Holy Vessels stolen from the Holy Temple were also engraved in the stone.

The chant of Kol Nidre still rang in his ears. He couldn't get Rebecca out of his mind. He could still see her with the satin kerchief covering her head. He had only one thought: the Triumphal Arch of Titus had been erected in honor of the victory over the Jews, but was it really a victory? The Jewish Rebecca could not be conquered.

⚜ Rome and Jerusalem

The moon had long since hidden behind clouds. The autumn wind was strong, the streets of Rome deserted. Only the disguised Pope walked the streets.

It was Yom Kippur eve and the Pope was thinking, *A holy night and a holy people...my people. My people are so weak and yet so strong! There are so few Jews in Rome, so few in number. Their ancestors either wandered here or were brought by Titus as slaves. And they have remained as permanent witnesses. They have witnessed mighty regimes come and go. They have seen nations rise, only to disappear. Only they and the pillars of marble remain. Are they then not stronger than the pillars of marble?*

He thought about his life and the life of his people. He was both the ruler of Rome and its prisoner. Did Titus, the destroyer of Jerusalem, bring him, too, to Rome as a slave? Jews had to bow their heads like slaves in the traditional coronation ceremony, but when they were in their own quarter, they were the proud, strong rulers of their own domain.

When will I no longer need to wear my disguise? When will I be among my brothers? And then and there he made a resolve! He would turn back. No one would be able to stop him—not Father Felix, not Tropea, not his own weaknesses.

True, he loved Rome, the city he knew so well. He had never been to Jerusalem. In his heart he had a strong yearning to go to Jewish Jerusalem. Jerusalem

was greater! So why did the world consider Rome to be greater? *He who is strong, rules. And what does Jerusalem say? He who is a believer, constantly strives for justice.*

And what do I gain from my power? Why do I need to rule? Can I be in Jerusalem and Rome at the same time? Can I be a Jew and not a Jew at the same time?

🕊 A Thief or a Spy?

Dawn was breaking as he approached the Lateran.

"Hey, stranger," called out the guards. "This is the Pope's residence."

"I am one of the Pope's servants and I am permitted to enter the Lateran."

"Give me the password for tonight," demanded one of the guards.

The Pope remembered that he had instituted the policy of requiring that those entering the residence give the password and that the password be changed each night so that no outsider would be admitted. He didn't want to let on that he didn't know this night's password that had been given to the guards by the Prefect who made the selections.

"Rome and Jerusalem," the Pope guessed.

"You'd better get away from here or we'll break every bone in your body!" laughed the guards.

The Pope left. He remembered how he had sneaked into the Lateran when he was a boy. He would at-

tempt to climb the wall to enter in the same way as he had then. He found the low point in the wall and began to climb over. Too late, he noticed two guards following him. They pulled him down from the wall.

"You are either a spy or a thief!" the guards shouted. "Come with us!"

"He must be a spy!" said one of the guards. "He's dressed too well to be a thief. Who knows what enemies have sent him?"

"He's a crafty spy. Let's take him to the Prefect," said the other guard.

Prefect Theobold got out of bed immediately.

"We have caught a spy," they told the Prefect. "He won't tell us his name."

"I want to speak to the Prefect alone," said the "spy." "Everything will be made clear very shortly."

The Prefect recognized the "spy." He was astonished and dismissed the guards. The Pope remained with the Prefect until midday. The Prefect sent for the Pope's garments.

Before the Pope left the Prefect's residence, he asked, "What was the code word for tonight?"

"The word was 'Yom Kippur.' I chose it because it is the eve of Yom Kippur for the Jews," answered the Prefect.

From then on, many stories circulated about the Pope. The Frangipanis said that the Pope had left his residence to commit crimes. The Pierleones said that the Frangipanis had hired murderers to kill the Pope.

✐ The Illegal Pope

On that night, Pope Anacletus II made another ene-
my—the Prefect of Rome. He had joined forces with
the illegal Pope, Innocent II, who was seated in
France. Innocent II now had the Prefect and the monk
Bernard of Clairvaux working for him. Many Chris-
tians were ardent followers of Monk Bernard, whom
they considered to be very holy. He gave many in-
flammatory speeches against Pope Anacletus II, the
Jew who had stolen the throne of the Papacy. Spain
and England were already in the camp supporting
Innocent II.

When the illegal Pope heard from the Prefect what
Anacletus II had done and that there was much hos-
tile gossip circulating about him, he decided that this
was the opportune time to defeat his antagonist once
and for all.

Just as there were two Popes, there were two Em-
perors of Germany: Lothair was the stronger of the
two and in control the throne. Conrad, his antagonist,
was in Lombardy. Innocent II sent emissaries to
Lothair to convince him to support his cause.

Convinced, Lothair and his knights went to Italy
to defeat Pope Anacletus II and replace him with
Innocent II.

In the meantime, the illegal Pope went to Pisa, a
long-time rival of Rome. He promised if they joined
him, he would favor their commercial status, so that

they would control all commerce. As a result of the promise, Pisa's navy was put into action in support of Innocent II.

Conrad, Lothair's antagonist, fled Lombardy. Lothair conquered all of the northern territories and was ready to march on Rome.

In Rome, the Frangipanis and the Prefect worked for Innocent II. Anacletus II was in a dangerous and precarious position.

"I will give up my position so that we can have peace," Anacletus II said to his trusted Cardinal, Petrus of Partus.

"No, you are not going to do that," the Cardinal said, "because no one will understand that your reason is that you want peace in the Church. They will say that the 'Jew' is scared. Besides, you cannot betray the trust of your supporters, who have been with you from the very beginning."

"But we must find a way to bring about peace!" said the Pope. "Wars are devastating. And those who suffer the most are the poor."

"We didn't start the wars and we are not to blame for them." The Cardinal ended the discussion with this statement.

Bishop Thomas

Anacletus II sent messengers to Emperor Lothair, to present the Pope's proposal: "Let the Emperor con-

vene an impartial council of all the Cardinals and leaders of the Church. Whomever they select will be the one and only Pope!"

Emperor Lothair had already reached Viterbo, which was not far from Rome, when the emissaries arrived with the plan. He was quite pleased with the suggested plan. He was not sure that he had enough knights with him to ensure a victory over the King of Sicily, who was a strong supporter of Anacletus II. The Emperor called his most trusted advisors and asked them to help him decide.

All but one agreed that the plan was a good one and that the conference should be convened. Only one Bishop among them strongly objected. His name was Bishop Thomas, and he bitterly hated Jews. He voiced his objection loudly and addressed those assembled:

"The Jew who usurped the Holy Throne now wants us to convene an impartial counsel. He will bribe Cardinals and will perform trickery and will see to it that he gets the majority of votes. All true Christians are against him! If the Emperor agrees to the plan, it will mean the destruction of the Church. We must get rid of the Jew who stole the Holy Throne."

He waved the large cross hanging around his neck before his colleagues while he delivered his diatribe.

"On to Rome! To Rome!" the Emperor decided.

"To Rome! To Rome! To save the Church and kill the Jews!" Bishop Thomas yelled to his colleagues.

⚜ The Abandoned Pope

Emperor Lothair reached the gates to Rome. The Prefect, Frangipani supporters, and other noblemen were there to open them and let them pass. The illegal Pope captured the Lateran and seated himself on the Holy Throne. The Emperor settled in the old Aventin that had seen many Emperors who preceded him. The Emperor's knights put up booths around the Church of the Holy Paulus. The ships from Pisa docked in the Tiber. The time had come when Pope Innocent II was to crown Lothair the King of Germany.

Only a few Cardinals remained loyal to Anacletus II. Only the common folk of Rome and all Italy remained true to Anacletus II. They were too weak to withstand the onslaught of the enemy, and King Roger was too far away.

Pope Anacletus sought refuge in the old Pierleone Palace. Later he moved across the Tiber to another palace where the fortification offered greater security. It was there, across the Tiber, that the Jews lived. He had changed his mind. He would not give in! He would not seek peace. He would show them that a Jew could defend himself!

Once an elderly Jew sought an audience with Pope Anacletus II. Everyone was aware that the Jews favored Anacletus II because they feared that Innocent II and the bishops who supported him would vent their hatred on all Jews.

The Jew was admitted to the Pope. He introduced

himself. "My name is Mesholem and I am from Regensberg," he said. "Once your Grace rescued my daughter from the Knight of Red Rock."

"I remember," the Pope interrupted. "And how is your daughter?"

"She is a dear soul," Mesholem said, "but she is strange. She doesn't want to get married. But I have not come because of her. Please tell me what we Jews can do for you. I, personally, owe you a great debt. The Jewish community does not want to sit idly by. Your enemies are our enemies."

"You can be of help to me. I have sent letters to King Roger, but I don't know if he received them."

"Give me whatever letters you wish and I will deliver them. I have been in very dangerous situations in the past and I survived. I know how to take care of myself. I assure you the letter will be delivered."

"I'm confident that the person who fearlessly threw himself under the hooves of my horses will succeed in the mission. There are those I considered to be strong who have deserted me. I am sure you will complete this mission successfully."

"Be assured that nothing will deter me!" said Mesholem, as he took the letter from the Pope.

⁊ In an Underground Cave

The Jews feared the knights that King Lothair had brought with him from Germany. They also feared

the monks who had come from many lands to support Innocent II, the illegal Pope. The monks vowed to kill the Jews and the knights joked with each other saying that they would rob the Jews of all their money and take their beautiful daughters.

The Jews had taken all the money, gold, and jewelry they owned and brought it to the Rabbi. It was part of Mesholem's plan. He spoke to the esteemed leaders of the Jews:

"If our lives should be in danger, it may be necessary to bribe the Emperor. They may take the bribes and leave us alone. So let us collect the money, gold, and whatever else we have."

Someone in the group called out, "But what can we do to save our daughters? Where can we hide them?"

The Rabbi spoke up, "Hundreds of years ago, Jews and Christians had to hide from the idol worshippers in Rome. So they dug underground hideouts that covered miles. Under Rome, there are many caves and plenty of room to hide our daughters. The Christians have long forgotten about these hiding places and how to access them. I, myself, will show my son where these hiding places are and have him supply them with food and water enough for our beautiful daughters while they are in hiding."

When Mesholem left on his mission to deliver the letter to King Roger, he felt certain that his dear daughter, Rebecca, would be safe from Lothair's Knights. Already many Jewish girls had been in the underground hiding place for a week. The girls were

divided into three groups, and Rebecca was the leader of one of the groups. She taught the girls songs and told them stories to lift their spirits and keep them from being sad. Rebecca knew that her father was on a dangerous mission. Whenever someone came to replenish the food supply, she would ask, "Has my father returned? Have you had any word from my father? What's happening in the city?"

"Yes, there is a big parade in Rome today. Pope Innocent II is crowning Lothair Emperor of the Holy Roman Empire. There is a big banquet. All his knights are drunk and your parents are glad that you are in hiding," the Chief Rabbi's son told them.

"Now would be a good time to attack them!" Rebecca called out. "My father delivered the letter to King Roger and we will be saved."

"I don't know what letter you're talking about," said the Rabbi's son. "In the meantime, you must remain in hiding and be very careful. I had the feeling that someone was following me on my way here. You must never tell anyone of the hiding place. You must all go deeper into the cave."

🦅 A Suspect is Captured

The supplier of food for the girls in hiding did not show up the next day. The girls were upset and hungry. Rebecca tried to comfort them and give them hope. Late at night, they were distraught. They had

no way of knowing what was happening in the city. They couldn't fall asleep. Several girls cried, while others prayed silently. Rebecca stood apart from her friends, listening for footsteps.

And indeed, she did hear footsteps above their hiding place. Someone was going one way and then tracing his steps back, as though he didn't know which turn to take in the tunnel. At times, he paused and then retraced his steps again and again. He had reached the hiding place where the girls had been the night before. Rebecca was frightened. She stood very still, her heart beating wildly. She strained to hear every step that was being taken. Suddenly, she jumped through an opening in the tunnel wall that led to the tunnel above.

In the darkness, she grabbed hold of a hand and a broad elbow that was covered by the cloak of a monk.

The captive was startled. When he recouped, he began to struggle. Rebecca clung to him with all her strength. She called out to her friends to come help, but before they were able to determine where her voice was coming from and come to her aid, Rebecca had taken quite a beating. However, she wrapped her arms around the captive and was able to hold onto him until the girls reached her.

By the light of a smoking torch that one of the girls brought with her, the frightened girls were able to make out this scene:

They could see Rebecca holding fast on to the captive. His eyes were bloodshot from rage. The girls en-

circled the monk. He mumbled under his breath, "Accursed Jews! Even in the underground, it's hard to get rid of them! We cannot escape them."

"Who are you and where do you come from?" Rebecca asked.

"My name is Bishop Thomas and I came into the tunnel to escape capture from King Roger. His knights are after me," the monk answered.

"Girls!" exclaimed Rebecca gleefully. "He is saved and so are we!"

"He? Who is *he?*" the girls asked.

"The Pope!" answered Rebecca. "Girls, we don't need to hide any longer!"

⚜ The Last Encounter with Father Thomas

"What are we going to do with the monk?" one of the girls asked, pointing at the captive.

"Let us take him to the Pope. It stands to reason that if the monk was running from the Pope's supporters, he must be someone of importance and has good reason to be fearful."

The girls left the tunnel, dragging the monk with them. They guarded him well and took him directly to the Lateran, where Pope Anacletus II was once again in charge. Innocent II had fled north faster even than King Lothair, who was fleeing from King Roger and his army.

Surrounded by guards, Bishop Thomas appeared before the Pope. And for the first time in history, a Jewish girl stood before the Pope. Her clothes were dusty and her eyes burning. Excitedly, she told how the captive appeared to be a monk but said that he was a Bishop.

Bishop Thomas recouped his composure and recounted his service and role in the Christian Church. He said he was "the right-hand man" for Emperor Lothair, and though he was against Pope Anacletus II, he was still a Bishop and an old man. He pleaded with the Pope to free him. He spoke of Christian love.

The Pope interrupted him. "And where was your Christian love when you were ready to wage war and disregard peace in the Church?"

The Bishop began to defend himself, but the Pope interrupted with another question. "As a young man, were you at one time a priest in Mainz?"

"Yes, I was a priest in Mainz as a young man," he confirmed.

"Then this is not our first meeting," the Pope said in a muffled tone.

"I don't remember." The Bishop was confused.

But I remember," said the Pope, and he ordered the guards to put the Bishop in a dark dungeon deep in the cellar and not give him anything to eat.

"We will decide his fate later," he said, and dismissed the guards. When they were gone, the Pope turned to Rebecca

"There was a time when I fell into his hands. To-day he has fallen into your hands. You are free to go now. Go, and be blessed. The day may come when I will tell you all that I know about Bishop Thomas."

☀️ Thomas's Punishment

Bishop Thomas could not remember where or when he had encountered the Pope in the past. He never again appeared before him. King Roger took the captive with him and left for Sicily. There they imprisoned him in a cloister.

A few months later, it happened that Queen Tropea went to the cloister where Thomas was being held. He fell to her feet and pleaded, "I beg of you, intercede for me with your brother, the Pope, to free me. He has been harder on me than on anyone else. He had me kept in a dark dungeon without food or water. I want to return to Germany, and I promise I will never again lift word nor sword against him!"

"I don't get involved in Church issues with my brother," the Queen told him. "He is a just Pope, good and kind. Why do you suppose he is harder on you than anyone else?"

"I have no idea. He told me that we had met before, but I don't remember where or when, and I have never met any of the Pierleones," he responded.

"What else did the Pope say to you?" she asked.

"The Pope asked me if had been a priest in Mainz. And I told him that I had been, but it was a very long time ago."

Tropea's eyes lit up. She ordered her guards to leave. When she was alone with the Bishop, she said, "There was a priest in Mainz who kidnapped a Jewish child. He tortured the child, beat him, and withheld food from him. When the child attempted to escape, he went after him with dogs. The child almost died."

The Bishop began to shake uncontrollably. "Is not the Pope a member of the Pierleone family? Is he not your brother?"

"No. An angry priest talked a foolish woman into kidnapping the child from his parents' home and turning him over to the Church," she told him.

The Bishop sat silently for a while and then said, "If I had not kidnapped him, he would not have been Pope. He should thank me!"

"For what?" asked the Queen. "You tortured him. You made his life miserable. You called him an accursed Jew. You fought to unseat him from the Papal throne and replace him with an illegal Pope. You made vicious and inflammatory speeches against him. What good do you imagine you did? He has nothing to thank you for!"

The queen rang for her servants. They came quickly and she ordered them to make ready for their departure.

Thomas was unable to sleep that night. He was

anxious and restless. He decided that he must escape and go to France to tell Bernard of Clairvaux the Pope's secret.

It was a cold winter night when he attempted to escape from the cloister. He bribed a guard to have a boat readied for him at the bank of the river. It was a stormy night; the waves were rough. Two days later a body which had washed ashore was found. The monks of the cloister recognized the body to be that of the banished Bishop Thomas. A messenger was sent to Queen Tropea with a letter informing her of the circumstances of his death.

✺ The Blind Beggar

After King Roger defeated Lothair and the illegal Pope, Rome and the greater part of Italy was under the control of Anacletus II. But he was totally separated from Germany and the other Christian countries beyond the Alps. Since those areas didn't recognize him as the Pope, he was surprised to learn that a blind monk from Bamberg sought an audience with him. He was told:

"The old monk is a beggar and requests an audience because he is a sinner. He says he has come a long way on foot and he will not confess to anyone but the Pope."

The Pope said he would receive him. When the

doors were opened to him, the old beggar fell to his knees and approached the throne. He crawled with his hand outstretched until he felt the Pope's garment. He lifted the hem to his lips and kissed it.

"What is it you wish to confess, my son," the young Pope asked the blind, gray-haired old monk.

"Holy Father," said the old monk, "I have sinned. A long time ago, I was an accomplice to the kidnapping of a child from his Jewish parents in Mainz. I was ordered to have the child forget his parents and raise him in the Church. To accomplish this, I lied to the child many times. I never let him out of my presence and placed him in circumstances where Catholic clergy would influence him. I now see the error of my ways. I should have taken the child back to his parents in Mainz. At the time, I thought I was doing a great service to the Church by bringing such an outstandingly bright child into it. I realize now that it was wrong. I have not served the Church well. I consider myself to be responsible for causing dissension and wars in the Church. Can I be forgiven for what I have done?"

The Pope had never before experienced such feelings of rage. His impulse was to jump from his throne and beat the monk that he recognized at first through his voice and then his face to be Father Felix. But he controlled himself. Instead, he calmly asked in a soft tone, "Do you know whom you are addressing?"

"I know," said the blind man. "But whoever is chosen Pope is my Pope, and I have come for absolution.

Three times, along the way, I prayed to God that I would not die before I got here. God has punished me with blindness. And because I have repented, he spared me for this journey."

"And at what point did you see the error of your ways?" the Pope asked quietly.

"When there was dissension in the Church and wars started over the selection of a new Pope. When I heard people refer to my Pope as 'the accursed Jew.' I realize now, that once a Jew, always a Jew."

🦢 The Rabbi of Mainz

"Is your sin only against the Church?" asked the Pope.

"No. I have also sinned against the child. When I left Rome and returned to Germany, I learned that the Rabbi had survived the slaughter of Jews by the crusaders. I should have gone to him then and told him who kidnapped his son. But, I didn't."

"Is the Rabbi of Mainz alive?" the Pope yelled out.

"I don't know, Holy Father," responded the blind beggar. "I was there so long ago. Can my sin be forgiven?"

"Your sin is forgiven, good Felix!" said the Pope.

"Bless me, Holy Father." The old man stretched his hands out to his former student.

The Pope placed his hands on the blind man's head and blessed him. He instructed his servants to pre-

pare a room for him and see to his needs. He was to live in the Pope's residence.

As soon as the old man had left the room, the Pope sent for his trusted Cardinal, Petrus of Partus, and said to him, "I want to see the Rabbi of Mainz. See to it that he's brought to me."

"The Archbishop of Mainz is not in our domain. He would not honor your commands. How can I get to him to see to it that the Rabbi is brought here?" asked the Cardinal.

"Wait," said the Pope. "We need to find out the name of the Rabbi of Mainz."

"The current Rabbi of Mainz is Shimon ben Isaac. He is the descendant of the Kalonymes family, who saved King Otto II by giving him his horse when the King's horse was killed in battle. The King rewarded him by taking him to Mainz. The Rabbi is greatly respected by his people. They call him, Shimon, the Great."

The Pope threw his arms around his trusted Cardinal and kissed him.

The Cardinal was taken aback. He asked, "Are the Pierleones also descended from the Kalonymes family?"

"I'm not concerned about the descendants of the Pierleones! But I am concerned with the Rabbi of Mainz!" the Pope told him.

To himself, the Cardinal said, "I have never understood Jews and never will!"

⚘ The Restrictive Law
Against the Jews of Mainz

A few days later, the Pope once again brought up the subject of the Rabbi of Mainz to the Cardinal, and he proposed a very strange plan:

"I know that if I gave the order for a law that would favor the Jews, it would not be carried out in Germany. They would say that the Jewish Pope is doing it for his brethren. But if I did the opposite and ordered a law that would be restrictive and oppressive, what do you think would happen?"

"It would be an interesting thesis to prove!" the Cardinal exclaimed.

The Pope was not angry at the outburst…just the opposite. He agreed with the Cardinal.

"I have given it much thought," continued the Pope. "I have decided that I will try it on the Jews of Mainz! Let us say that we order that the Jews of Mainz are forbidden to observe their Sabbath. Will the Archbishop honor that law?"

The Cardinal could not believe his ears. He heard the Pope say that the following order was to be issued:

"From this day forward, the Jews of Mainz are forbidden to observe their Sabbath!"

The Archbishop of Mainz called the leaders of the Jews together and read the law:

"Jews are no longer permitted to go to the syna-

gogue on their Sabbath; Jews are not permitted to dress in Sabbath clothes; Jews are not permitted to close their shops on Saturdays; they must do business on the Sabbath as they do the rest of the week. Anyone who disobeys this law will be expelled from Mainz."

When the leaders relayed this terrible law to the Jewish community, they grieved and called a fast day. They gathered in the synagogue where the Rabbi addressed them.

"Be strong! Be courageous! The Sabbath is greater and more important to us than our homes and all our material possessions! We will do what is necessary to try to have this bad law revoked. If we cannot succeed, we will once again take up our wander sticks and move from here. We will never give up our Sabbath."

The Jewish leaders collected whatever money they had and took it to the Archbishop, asking him to rescind the law.

"I cannot do that," he said. "This order has been given by the Pope. Only he can rescind the law."

"Then we will go to Rome and plead with the Pope to revoke this law," said the Rabbi. "In the meantime, we beg the Archbishop to delay carrying it out."

The Archbishop agreed not to put the law into effect immediately.

The elderly Rabbi and two other leaders of the Jewish community set out for Rome.

🕊 It Cannot Be!

When Rabbi Shimon and the other two leaders arrived in Rome, they immediately went to see the Chief Rabbi of the Jewish community. Rabbi Shimon's reputation preceded him. The Chief Rabbi was overjoyed to receive such an honored guest. He was distressed and surprised when told of the terrible law the Pope had ordered against the Jews of Mainz.

"Are you sure that our Pope issued that order?" he asked. "He is the grandson of Jews. He is our protector. We thank God that he is the Pope."

"We have actually seen the order with the Pope's seal on it," said the leaders of Mainz. "We need your help. Do you think we need to give the Pope a big gift?"

"The Pope doesn't need our money," the Chief Rabbi of Rome told them. "There must be some mistake. But of course we'll help you! I, myself, will go with you to see the Pope. We will also take with us a Jew from Regensberg. His name is Mesholem, and he is well acquainted with the Pope. Once the Pope rescued his daughter and once Mesholem successfully completed a mission for the Pope."

The Rabbi summoned Mesholem and told him what had transpired with the Jews of Mainz. Mesholem went home and told his daughter.

"It can't be!" Rebecca raised her voice. "The Pope would never put his seal to such a bad law!"

"Don't raise your voice, Rebecca. The Jewish leaders of Mainz are here. They have seen the Pope's seal on the law with their own eyes. They have come to plead for its revocation."

"I will go to the Pope and ask him to repeal the law!" Rebecca said with determination.

And, for the first time, Mesholem yelled at his daughter. "What are you talking about? Is he *your* Pope? Do not talk about him and do not think about him!"

"It can't be! It just can't be!" Rebecca stubbornly repeated.

✒ The Delegation

Three Jews from Mainz and two from Rome fasted that day. They were anxious and worried as they waited impatiently for an audience with the Pope. They were kept waiting for a long time, and then were told, "The Pope will only see the Jews from Mainz."

The Chief Rabbi and Mesholcm had to leave. The delegation was nervous. Later, they were told, "The Pope will only see the Rabbi of Mainz."

Rabbi Shimon remained alone. The Pope gave audiences to many groups before the old Rabbi was summoned. When he entered the hall, he saw that the Pope was alone.

With his head bowed, the Rabbi approached the throne, where he saw a man in his forties wearing a bright red mantle. The Pope got up from the throne and walked up closer to the Rabbi and asked him to be seated. He took the seat next to him.

The Rabbi was confused. He wanted to talk about the oppressive law, but the Pope interrupted him.

"Later, later," he said. "Is your...how is your wife?"

"When I left Mainz, she was well but very worried about the law instituted against the Jews, and—"

"Do you have children? How many children do you have?" the Pope interrupted.

"I don't have any children. God has punished me and I have no children to comfort me in my old age."

"Did you never have children?"

"I did have a son, a precious boy—"

Again the Pope interrupted. "Did your son die?"

"Even worse! He was kidnapped." Tears formed in the old man's eyes. "We had no other children. Our son disappeared; we know not what happened to him."

"Don't dwell on the sorrows of the past. Let us forget them. And don't worry about the present. The present-day sorrows will pass, too. I have heard that you are a master chess player. A round of chess takes your mind off your worries. One needs to concentrate on the moves."

✌ A Round of Chess

"But I have come to talk about the oppressive law," said the astonished holy man from Mainz.

"There is a table set up in the corner for a game," the Pope said, pointing in the direction of the table. "Let's go there."

As a man walking in a trance, the Rabbi went to the table and prepared to play a round of chess with the Pope.

"You will have the white chessmen, and I the black. Let's play!" said the Pope.

The Rabbi could not understand the strange turn that the audience with the Pope was taking. He never expected that he would be playing chess with the Pope!

Automatically, he made the first move. He moved his king's pawn up two squares. At the time, this was a very unusual opening move to make. Ordinarily, the game would begin with moving the rook's pawn. He thought this move would surprise the Pope. But the Pope moved his own king's pawn up two squares. The Rabbi then moved two squares ahead with his bishop's pawn on the king's side. The Pope didn't think too long and moved his own queen's pawn ahead two squares. The Rabbi leaned back on his chair and put his hand across his face. This was the opening that he himself had developed. He always opened the game this way when he played black

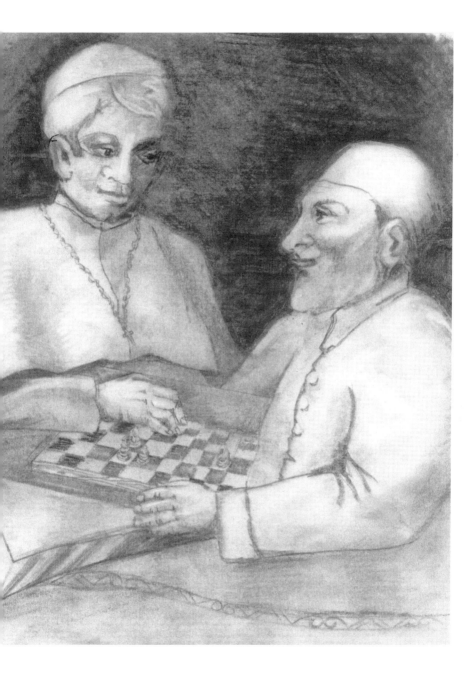

against a white opponent. He was willing to sacrifice his pawn on the second move. He wondered how someone would know these moves who had never before played with him?

Suddenly, his mind went back in time. He could clearly see the image of him sitting on a bed beside his sick child; his son was sick in bed with a terrible cough and wasn't allowed to go out. It was Friday and the house had good aromas of Sabbath food cooking. He remembered sitting on the bed and teaching his son these very chess moves. The Rabbi looked deep into the eyes of the Pope. The Pope stared at the Rabbi.

ᔐ Father! Father!

"Father! Father! Don't you recognize me?" the Pope said loudly and threw his arms around the Rabbi.

The Rabbi recognized his son. They were both silent for a long while. Silently, the Rabbi's lips moved in prayer.

His newfound son asked, "Is there some way for me to be forgiven my sins? Is there a way for me to return to my roots?"

"Are you sure you want to return and leave all this wealth and power?"

"Of course I do. If I didn't, I wouldn't have concocted this extreme plan so that you would be able to

come to me. I hate being Pope. I want to be the Jew I was born to be. I have always wanted that."

The father and son had a long talk. The son told how he had fought and struggled against his kidnappers and how he had been taken to Rome. He recounted his life as a member of the Pierleone family. He told how he had discovered the news of the Jews murdered in the Crusades. He told him how he had yearned all these years to return to him and his mother. He also told him of the sins he had committed.

Elkhanan was sad. His voice broke as he asked, "Will you allow me to return to Judaism? May I live among Jews again? Or would it be better if I jumped from the tower of my palace and ended my life?"

"What are you saying, my child?" said the Rabbi. "You will come back to your mother and me and we shall take pride in your future. Perhaps you'll marry and give us grandchildren."

They decided that the delegation from Mainz would return to their homes the following day. The Pope gave the Rabbi a letter with his seal revoking the oppressive laws against the Jews of Mainz. The Rabbi told the Chief Rabbi of Rome that he had accomplished his mission. He told no one of his reunion with his son. The Pope was to leave Rome as soon as he could and meet his father in Viterbo. The Rabbi was to wait for his son there.

The Pope accompanied his father out of the Later-

an and provided him with a guard who was to accompany him on his journey. It was late at night. As for the Pope, he sat down to write.

He continued to write into the wee hours of the morning. It was an announcement for all the Popes who were to follow after Pope Anacletus II. It was to be read by the Holy Petrus of Partus. In the announcement, the Pope asked that Jews be allowed to practice their religion in peace. "They are an eternal people," he wrote. His concluding sentence was *"I was born a Jew and I will always remain a Jew!"*

✍ Someone Jumps Off the Roof

Anacletus II went up to the roof. Dawn was breaking. The wind cleared his mind from the events of the long day and from having worked on the composition of an announcement all night. He stood very still behind the chimney.

Suddenly, he heard a voice saying, "Here—I know this is his bedchamber. Half our job is accomplished. The rest is easy. We can lower ourselves over here." The Pope looked at a spot on the roof where he could see two shiny knife blades in the hands of the men who were standing at the rim of the roof. He thought *If this were a usual night for me, I would have been stabbed to death in my bed. Who knows how they were able to get to the roof without alerting the guards.*

The two men were hired killers. They put their knives between their teeth and were getting ready to climb down the water pipe into the Pope's bedchamber. The Pope stood very still and then suddenly and quickly pushed one of the hired assassins with all his strength. The hired killer fell to his death. The other lost his hold of the pipe and jumped down to the ground and ran away as fast as his legs would carry him. The Pope didn't summon anyone. He went to his room and changed his clothes into those of a servant and waited for the activity of the day to begin. When the night guards left their posts at the door, he unobtrusively followed the servants out.

A dead body was discovered at the foot of the Lateran. The Pope was nowhere to be found when the guards went to report to him. Petrus of Partus read the announcement left by Anacletus II, which he had found on the desk. The clever Cardinal sent word to Innocent II to come to Rome, saying that the Jewish Pope had jumped from the roof of the palace.

The hired assassin was buried as the Pope. In the annals of the historical record of Popes, it read, *"Pope Anacletus II jumped off the roof to his death."*

🌾 Do You Know Who He Is?

A servant knocked on the door of the house where Mesholem lived with his daughter, Rebecca.

"I come with a message from the Pope," he said.

But as soon as he walked through the door, both father and daughter recognized him. They didn't show their surprise when Elkhanan said, "Come, let's all go home to Mainz. My father, Rabbi Shimon is waiting for us in Viterbo."

Mesholem was perplexed. He didn't understand the strange statement. But it was clear to Rebecca, and she understood what Elkhanan was saying. She embraced Elkanan and said, "Let us go, my dear groom. We were destined for each other. I have waited for you long enough!"

A canopy was set up in Viterbo. Mesholem wanted to prepare a big celebration in Mainz, but the Rabbi and his son discouraged it; it was too dangerous. No one must know the groom's past. Rebecca and Elkanan lived with the Rabbi and his wife as was the custom for young married couples. The old father studied Torah with his son....

* * *

Some years later, there was a conference in Mainz. Three communities came together—Speyer, Worms, and Mainz. In honor of this occasion, Rabbi Elkhanan, son of Rabbi Shimon, addressed the group and pre-

sented a proposal: the three communities should ob-
serve the same customs and work as a cohesive and
unified group to determine any future innovations.
The proposal was accepted unanimously.

Whispering to one another, those assembled said,
"Do you know who Rabbi Elkhanan was? He was the
Jewish Pope!"